IMAGES OF ASIA

Traditional Chinese Clothing

Traditional
Chinese Clothing

in Hong Kong and South China, 1840–1980

VALERY M. GARRETT

HONG KONG OXFORD NEW YORK
OXFORD UNIVERSITY PRESS
1987

Oxford University Press

Oxford New York Toronto
Petaling Jaya Singapore Hong Kong Tokyo
Delhi Bombay Calcutta Madras Karachi
Nairobi Dar es Salaam Cape Town
Melbourne Auckland

and associated companies in
Beirut Berlin Ibadan Nicosia

© Oxford University Press 1987
First published 1987
Published in the United States by Oxford University Press Inc., New York

OXFORD is a trade mark of Oxford University Press

Library of Congress Cataloging-in-Publication Data

Garrett, Valery M., date
Traditional Chinese clothing in Hong Kong and
South China, 1840–1980.
(Images of Asia)
Bibliography: p.
Includes index.
1. Costume—China—History—19th century. 2. Costume—
China—History—20th century. 3. Costume—Hong Kong—
History—19th century. 4. Costume—Hong Kong—History—
20th century. I. Title. II. Series.
GT1555.G37 1987 391'.00951'2 87-22035
ISBN 0-19-584174-3

British Library Cataloguing in Publication Data

Garrett, Valery M.
Traditional Chinese clothing: in Hong Kong
and South China 1840–1980.—(Images of
Asia).
1. Costume—China—History
I. Title II. Series
391'.00951 GT1555
ISBN 0-19-584174-3

Printed in Hong Kong by Nordica Printing Co.
Published by Oxford University Press, Warwick House, Hong Kong

Preface

THE idea for this book was conceived in the summer of 1978 when I discovered during my search along library shelves that very little had been published in English on everyday Chinese clothing. Court and formal costumes of the Qing dynasty were well documented in museum publications, but information on the clothing worn by common people seemed sadly lacking.

This small book does not claim to be a comprehensive study of Chinese costume as a whole: the country is too vast and its ethnic groups too diverse. But the New Territories of Hong Kong were a good place, before urbanization encroached more and more at the beginning of the 1980s, in which to take a closer look at how life would have been lived in the rural areas of south China during the early part of this century. My purpose, then, was to look at the different types of clothing and to record what little of them remained before they disappeared forever.

Although the Pinyin system of romanization has been in use in China for some years and has been adopted in many parts of the world, Hong Kong still retains its own romanization for local names and terms based on the Cantonese pronunciation. For this reason names pertaining to China in this book are expressed in Pinyin, while those pertaining to Hong Kong as well as terms of Cantonese origin and relevance are expressed in romanized Cantonese, with their Pinyin equivalents given in the glossary.

Many people have helped me over the years. The encouragement and assistance throughout from Dr James Hayes, Regional Secretary, New Territories, has been in-

valuable. In particular I would like to acknowledge his assistance with the compilation of the glossary. I am also grateful to all the District Officers and their staff for their help and co-operation. Special mention must be made of the villagers in the New Territories who answered my seemingly endless questions with much patience and courtesy. Thanks are also due to the Hong Kong Polytechnic for their help in the initial stages of my research, to my two able assistants, Josephine Chan Ka-wai and Regina Yu Yuet-fai, and last but not least to my husband, Richard, for his continuing support.

VALERY M. GARRETT
Hong Kong, 1986

Contents

I
Introduction

THE largest ethnic group in Hong Kong and in the Chinese province of Guangdong to the north of it is the Cantonese, whose dialect is spoken and understood by the majority of the population. Originally the Cantonese lived together in clans (in Chinese genealogy a clan is a group of individuals descended from one male ancestor) in a village founded by the first ancestor, and their roots go back for centuries. Indigenous Cantonese refer to themselves as Punti, literally 'local people'. Many Punti villages in Hong Kong were established before the beginning of the Qing dynasty in 1644, and the Tang clan, for example, can trace its lineage in Hong Kong back to the tenth century when its founding ancestor settled in Kam Tin in the New Territories.

Another large group is the Hakka, a term meaning 'guest people' or 'strangers' and applied to a group not indigenous to the region. It is thought that they originated from the provinces of Shandong and Henan in northern China, from whence persecution over successive dynasties caused them to move further and further south until they reached the southern part of Guangdong during the Qing dynasty. Being latecomers to the region, the Hakka people tended to live and work in the poorer, more mountainous areas where their common occupation was farming. They speak a dialect less akin to Cantonese than to the northern dialect spoken in the Beijing region (now no longer a dialect but the national spoken language).

A third ethnic group is the Hoklo, a Cantonese term meaning 'men from the Hok', that is, Fujian (Hokkien) province, and the south-east coastal region as far south as

Hainan Island. These people constitute a good part of the fishing population, and speak local dialects of Shantou (Swatow), Chaozhou (Chiu Chow) and Xiamen (Amoy). In the past large numbers emigrated to the Straits Settlements of Singapore and Malaysia.

Tanka (or the Cantonese term 'Daan ga') is the popular name given to another section of the floating population in the region. The term, dating back to the Song dynasty, means 'egg people', though its derivation is obscure. The Tanka dislike the name and prefer 'Shui sheung yan', which means 'people who live on the water'. Because of their different physique and darker skin, they were traditionally thought by those living on the land to be a race of sea gypsies and not Chinese at all, but the Tanka people refute this. Originating from the coastal regions of Fujian and Guangdong provinces, the Tanka were from early times forbidden to live on land, to intermarry with people on land, and to sit for the imperial examinations, success in which might have improved their lowly status. However, during the early days of the Republic they were given equal rights to those of people on land, although even now the extent of illiteracy among Tanka people is greater than among other groups due mainly to their irregular education.

2
Adult Clothing

THE Qing dynasty (1644–1911) was a period when China was ruled by the Manchus, formerly a nomadic tribe from the region beyond the northern frontier of China later known as Manchuria. Although southern China was quite remote from the court in Beijing, the area was still governed by provincial officials ultimately responsible to the Manchu court until the middle of the nineteenth century when Hong Kong island, and later Kowloon and the New Territories, came under the jurisdiction of the British. Han Chinese men who had attained positions of power in the government by passing the imperial examinations wore Manchu-style robes for formal occasions such as government business, celebrations and festivals, and their own Han Chinese-style robes for informal wear. Chinese women did not wear Manchu clothing (Vollmer, 1983).

The Manchus, having been hunters, had developed their style of clothing from the characteristics of the skins of the animals they hunted, whereas Han Chinese clothing was based on a tradition of weaving whereby the width of the cloth determined the style of the garment. The *sam fu* (a generic term formed of *sam*, meaning the upper garment, and *fu*, meaning the trousers) was the outfit most commonly worn by the Chinese people in Hong Kong and south China. Both garments were based on lengths of cloth woven on a narrow backstrap loom, thus necessitating several seams, and because the production of cloth was a fairly slow and laborious process, the cutting of the *sam* and the *fu* had to be done in the most economical way possible.

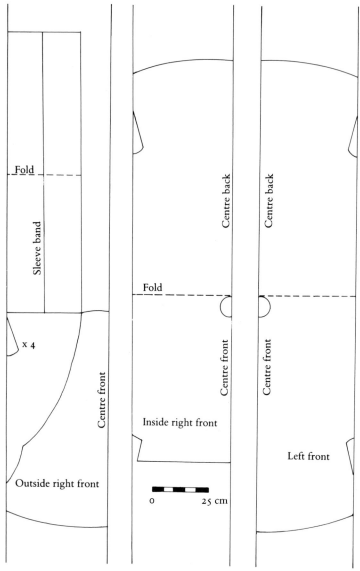

1. Layout of woman's cotton *sam, c.* 1865–1900

The *sam*

One width of cloth formed one half of the front and back of the *sam*, with a folded edge at the shoulder. Another width made the opposite side, while sleeves were made from strips of cloth attached to the edges (Figure 1). An overlap which imitated the Manchu style derived from animal skins was added to the right side for extra covering and protection, and the garment fastened with loops and toggles, again a Manchu derivation. However, because the garment was cut from cloth and thus likely to fray, the ancient Han Chinese tradition of outlining the edges of the *sam* with bias-cut bands was adopted for reinforcement, and later for decoration. This method of construction

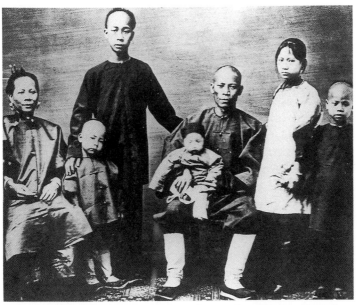

2. A shopkeeper and his family wearing the *sam, fu* and jacket, Guangzhou, 1861–4 (Source: Dr J.R. Jones, in Warner, 1976)

formed the basis of all upper garments worn by the Chinese. As well as being economical in cut, it made for a style of garment which was easy to store, folded flat in camphor wood chests.

The *sam* was worn originally by both male and female. Later, however, the overlap on the *sam* was dispensed with by men, and replaced by a jacket with a centre front opening worn as an outer garment (Figure 2). Women continued to wear the *sam* which, from the mid to the late nineteenth century, was cut very large and long, reaching to the calf, with wide sleeves. As fabrics took a long time to produce and were costly, generously-cut garments, which indicated that there had been no economizing on the material, reflected wealth on the part of the wearer. Women from important families in the urban areas, and wives of merchants and tradesmen wore the *sam* made from silk damask, with wide plain and/or embroidered bands at sleeves, neck, hem and the curved opening called the *tau kam*.

In the nineteenth and early twentieth centuries, the majority of people outside urban areas were engaged in one or the other of the two main occupations: fishing and farming. Hard-wearing fabrics were used for everyday clothing: hemp, which was grown locally up to sixty years ago; black gummed silk (*hak gow chau* or *hak gow sa*); and cotton (Figure 3). The well-to-do would employ a sewing amah to make clothing for the family, while poorer families would make clothing for themselves, or buy ready-made clothes from tailors or hawkers.

The *sam* was worn by all ethnic groups and is still worn by the more traditional women in the outlying areas in Hong Kong. In the past it was usual for Hakka women to wear a wider, longer *sam*, while the more sophisticated Punti women wore a shorter, fitted style with a higher

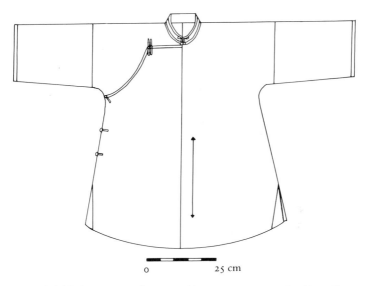

3. Purplish black cotton *sam* from a wedding trousseau, San Tin, Hong Kong,
 c. 1940

collar. The style of *sam* worn by Hoklo women changed
little over the last fifty years. It was more fitted than that
worn by the Punti and Hakka, and was distinguished by
its deeply curved hem and edging of a contrasting colour.
The very narrow collar consisted of two rows of piping,
usually of black gummed silk, to match the piping and
bands at the sleeves and *tau kam*. The sleeves were long and
narrow, and there was no pocket as this was unnecessary
on a boat. Although most of the *sam* were made of cotton,
those worn by older women were sometimes of wool.
Colours were brighter than those worn by the Punti or
Hakka, often with pale blue for every day, and purple,
deep blue or deep turquoise worn over black *fu* for special
occasions (Plate 1). In the summer women wore light-
coloured cotton or polyester-cotton *sam* made of men's

shirt prints. These either had short sleeves or were sleeve-less, and in the cooler months would be worn as under-wear.

Tanka women, particularly the younger ones, preferred light, bright colours. Pale green or blue, turquoise, yellow and pink were popular with young women, especially when newly married, and on special occasions, while darker colours, particularly black gummed silk, were worn by older women. The *sam* and *fu* matched in colour, the former being fitted, often darted at the waist, with long tight sleeves, a narrow collar band and sometimes a little contrast piping as decoration.

The *fu*

As with the *sam*, the style of the *fu*, or trousers, also origin-ated from the nomadic Manchus who wore animal skins wrapped round their legs while on horseback to prevent chafing. Later, when leggings were made of cloth, ties at the ankles and waist were added to keep them in place. Still later, tubes of cloth attached to a waistband became the forerunner of the *fu*.

Leggings were worn over a loincloth at first, and then over trousers. On formal occasions men concealed their leggings with long robes, but as casual wear leggings were teamed with a jacket or *sam*. Shorter leggings con-tinued to be worn by women until the early years of the twentieth century, as they helped to conceal the swollen ankles caused by foot-binding.

Unmarried women wore trousers with their *sam*, whereas middle- and upper-class married women hid their trousers under a skirt. These trousers were cut as straight tubes of fabric, with gussets to form the crotch, and were attached to a cotton waistband. The hems were decorated

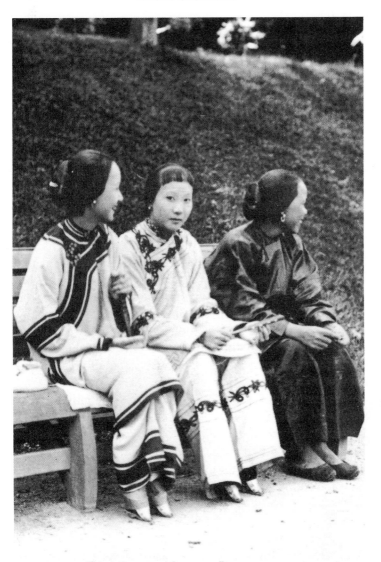

4. Two girls wearing decorated *sam* and *fu*, with bound-feet shoes, accompanied by their maid, Hong Kong, 1890 (Source: Urban Council, Hong Kong)

with bands of silk or embroidery, often to match the accompanying *sam* (Figure 4).

Fabrics for the *fu* were similar to those used for the *sam*, although the two garments were not always made as a set. Hemp, grown locally and made into cloth, was favoured as it was cool to wear. Cotton, black gummed silk and hemp were the usual fabrics worn by the lower classes, though worsted wool, fleecy cotton and rayon enjoyed short spells of popularity after the Second World War. Silk was generally favoured by the middle and upper classes, with some black gummed silk for everyday wear.

As with the *sam*, the cut of the *fu* was determined by the width of the woven cloth, with full and half widths utilized economically; early styles had four seams at front and back, later changing to two (Figure 5). Black and blue were the most popular colours for the main part, while the waistband, which seldom matched, was blue, black or the natural off-white colour of the cloth. The waistband was called *fu tau*, literally 'head of the trousers'. A white waistband, whether on trousers or skirt, was fancifully referred to as *baak tau do lo*, literally 'white head/waistband, old age'—the sign of a desire for long life. The fabric of the waistband was never the same as the main part of the *fu*: it was of a lighter, coarser quality to prevent the garment from slipping down. The wide waistband, which helped the wearer to step easily into the *fu*, was folded across the body, secured with a belt or cord, and the surplus cloth tucked in.

Men's jacket and *cheung sam*

The centre-opening jacket, worn by men as an outer garment, was cut in a similar manner to the *sam*, only without

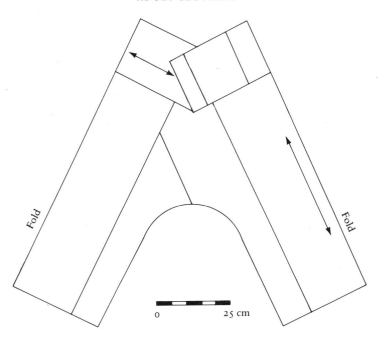

5. Four-seamed style of *fu*, Hong Kong, early twentieth century

the outside flap at the right-hand side. The sleeves were longer and wider, and around the neck, like the *sam* style of the time, was a narrow piped band, which later developed into a small stand-up collar. The jacket reached to the hips, and was worn over a *cheung sam* by the well-to-do on formal occasions, and over matching *fu* by all classes for more casual wear.

A calf-length centre-fastening surcoat was also worn on formal occasions. The coat would have badges of rank (sometimes called mandarin squares) fixed to front and back to indicate the wearer's official status if he had reached a high position in the government.

Early styles of jackets had no pockets, these being added

only later; by the 1950s three or four outside pockets were common, and often there were two or three hidden pockets inside as well. These hidden pockets were called *doi hau*, literally 'pocket mouths', the implication being that the wearer of the jacket had many mouths at home to feed.

The centre front of the jacket fastened with an odd number of loops and buttons, odd numbers being considered lucky and adhering to the *yang* or male principle. During the nineteenth century five were popular, followed by seven, nine, and even eleven for the man-about-town, but seven became the established number and has remained so up to the present day.

Sleeveless jackets, which were cut in the same way as the long-sleeved styles, were worn in warm weather by younger men and labourers. A much more formal style, worn as an outer garment over a *cheung sam*, was the side-fastening waistcoat based on the style of the Manchu robe. The sloping shoulder seams and the fastening down the side point to a garment which had developed from animal skins where one skin made up the back and two overlapped at the front for warmth and extra protection. A variation of this style, which originated from the use of two skins, was a plastron style which fastened across the top front and sides to an extended back piece (Vollmer, 1977). A later development was the centre-opening sleeveless style with a wide collar and sloping shoulder seams. These formal waistcoats were often made of silk damask edged in plain satin or velvet.

Fabrics for jackets were cotton, hemp, black gummed silk, and some wool and wool mixtures, although wool was never very popular with the Chinese. Colours were sombre, the most common being blue and black, although light-coloured checked and striped silk teamed with

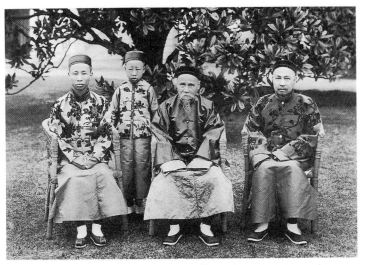

6. Four generations, aged 13 to 85 years, all wearing *pui sum* or *ma kwa* over *cheung sam*, Hong Kong, 1913 (Source: Public Records Office, Hong Kong)

matching *fu* was popular for summer in the years following the Second World War. For additional warmth in the cold weather jackets were often lined with cat or dog fur as well as goatskin or sheepskin. Another means of warmth was layers of wadded cotton, stitched in vertical lines to hold the wadding in place. Sleeveless jackets were often wadded in this way. As styles changed little over the years, fur-lined jackets would pass from father to son as part of his inheritance. It was also the custom for rich and poor to pawn their fur-lined garments during the summer months; this way they would be stored under better conditions.

After the founding of the Republic of China in 1912 formal wear for men became a short jacket reaching just below the waist and known as a *ma kwa*, literally 'riding jacket', worn together with a *cheung sam* (Figure 6). This

ensemble became the official dress for men of importance on ceremonial occasions and when worshipping at the temples. In the New Territories of Hong Kong men elected to represent their village in negotiations with other clans or with government bodies would don the *ma kwa* and *cheung sam* when on official business.

At first the *ma kwa* fastened over to the right but later, as with the everyday jacket, it fastened down the centre front, with five loops and buttons. It had a small stand-up collar and slits at the side seams and centre back. The fabric was usually black silk damask lined with blue silk, the damask with designs of bats (symbol of happiness), stylized renditions of the character for long life, and other auspicious emblems in the fabric weave, these usually being placed in set formation at centre front, back and over the sleeves.

Under the *ma kwa* a man would wear a *cheung sam*. Nowadays the term *cheung sam* is generally applied to the fitted dress worn by women, but the term literally means 'long dress' and can apply equally to the long gowns worn by men of some social standing in the Qing dynasty and up to recent times. Like the *sam* but longer and reaching to the ankle, the side-fastening gown, based initially on animal skins, had slits at the front and back added by the Manchus, in addition to those at the sides, for ease when riding. The Chinese adapted the *cheung sam* to suit their more sedentary way of life by closing up the centre back and front slits and by replacing the narrow horse-hoof cuffs with wider sleeves. There were no pockets in the earlier gowns; like the Manchu hunters the Chinese would wear a girdle around the waist, attached to which would be purses to hold the accoutrements for daily use: fan, snuff bottle, tobacco, a pair of chopsticks and a most precious possession, a watch.

Sleeves were made very long, partly for warmth but also to cover the hands which it was considered impolite to show. For formal wear the cuffs would be worn down, but for casual wear they could be turned back. Sometimes the cuffs of the undergarment would be turned back over the top one; at other times, for a touch of elegance, detachable white cuffs were worn. Before the introduction of pockets into the side seams or on to the inside flap at the end of the nineteenth century, the sleeves served as a place in which to keep small objects, hence the origin of terms such as 'sleeve full of snuff', 'sleeve editions' (miniature books), 'sleeve scrolls' (miniature paintings), and even 'sleeve dogs' (small Pekinese or lap dogs) as all these items were carried in the sleeves.

A man's summer *cheung sam* was made of cotton, linen (ramie) or silk, while winter clothing would be made of wadded silk or cotton. Silk lined with fur was popular, and more recently wool mixtures were used.

When fully attired for an important occasion a man would be wearing his black *ma kwa* over a blue, or sometimes grey, *cheung sam*; on his feet would be black cloth shoes and white socks, and on his head a black skull cap (Figure 7). If a man had reached his sixtieth birthday he might also wear an embroidered square on the front and back of the jacket. These squares were the later equivalent of the badges of rank worn by high officials in the Ming and Qing dynasties. A feather fan or folding fan would complete the outfit.

Women's *cheung sam*

Like the men's long gown, the *cheung sam* for women developed from the robes worn by Manchu women during the Qing dynasty. Those worn by the Manchus were loose

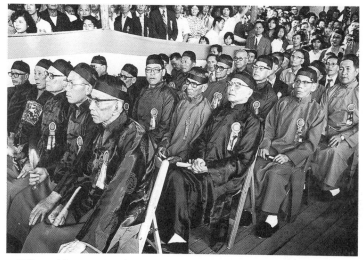

7. Village elders wearing the *ma kwa* and *cheung sam* at Ta Tsiu ceremony, Tap Mun, Hong Kong, 1979 (Source: South China Morning Post)

fitting as it was considered indecent to show the shape of the body, but the Chinese version was quite the opposite, being tight fitting with a high collar and *tau kam* fastening over to the right side as on the *sam*.

After the end of the Qing dynasty, an outfit was introduced to replace the cumbersome robes worn in the past by middle- and upper-class women. This outfit consisted of a long top reaching to below the hips and worn over an ankle-length skirt, pleated or plain, or over trousers. It was seen as 'modern dress' and reflected the greater freedom enjoyed by women. The top was slightly fitted, with tight sleeves long enough to cover the hands. The collar was high, as high as it would ever be, with the corners sometimes turned down. There was a point at the centre of the *tau kam*, all the edges were trimmed with braid, and the side slits were short, reaching to the lower hip.

8. Prominent Chinese women wearing the forerunner to the *cheung sam*, Guangzhou, *c*. 1922 (Source: Seton, 1924)

By the early 1920s the upper garment had become narrower and finished at the top hip, with the hem slightly rounded. The sleeves were three-quarter length with wider cuffs, and the collar was reduced to a more comfortable height (Figure 8). An alternative style was a sleeveless top with a square neck worn over a plain blouse cut like a regular *cheung sam*. The skirt was now a simple flared style finishing at mid calf. Then by the middle of the 1920s a combination of the top, blouse and skirt created the *cheung sam* as we now know it. At the time it was considered a very daring style for women as it was regarded as a style for men only.

Following the establishment of Nanjing as the capital of the Republic of China in 1927, two styles of clothing were stipulated as formal wear for women. The first was a black jacket and blue skirt which were cut like the

earlier outfits, with a straight band collar and the fastening down the right-hand side with buttons and loops. The jacket had three-quarter-length sleeves and reached to the top hip while the skirt reached the ankle. The second style was the *cheung sam* (called *qi pao* outside of south China) which had a band collar, six-button fastening and three-quarter-length sleeves. The length was to mid calf and the colour had to be blue.

By the end of the decade the sleeves had shortened to above the elbow and widened, while a curved hemline rose to just below the knee, coinciding with the shorter lengths of skirts worn in the West. Around this time too greater emancipation for women resulted in better educational opportunities and with this the need for a school uniform which reflected the Chinese style of dress. In place of Western gym-slips or sailor suits, girls wore a plain cotton *cheung sam* with wrist-length sleeves and short slits at the side of the hem. Even today several girls' schools in Hong Kong still retain the *cheung sam* as uniform.

At the beginning of the 1930s the *cheung sam* became much tighter fitting with slits on both sides of the hem. The very fashion-conscious woman wore an ankle-length version with side slits reaching right up to the thigh, emphasized by legs clad in silk stockings (a recent innovation at that time) and high heels. Sleeves were either tight to the wrist or, in summer, short or non-existent.

By 1940 the collar was a medium height and the sleeves shortened to small cap sleeves, or they were completely dispensed with (Figure 9). The opening at the top now extended to the left side, while the hemline rose to mid calf and the garment became more fitted. With the takeover by the Communists in 1949, the *cheung sam* disappeared in mainland China, but in Hong Kong women continued to wear it. The styling was semi-fitted with a high-waisted

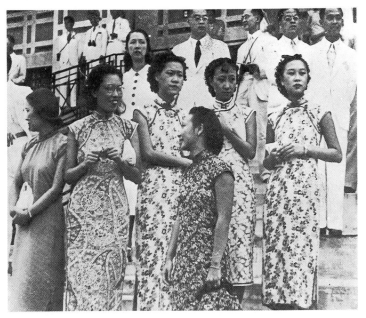

9. Group of women at Happy Valley Race Course wearing the *cheung sam*, Hong Kong, *c.* 1940 (Source: Urban Council, Hong Kong)

look and set-in sleeves, and the dress fastened with press studs or a zipper in place of the rather fiddly loops and buttons.

With the introduction of the miniskirt in the West in the 1960s the hemline again rose and the collar height increased, but during the 1970s the hem settled at just below the knee, and the collar became a more comfortable height. Shoulder openings and sleeve lengths changed with the tides of fashion, and detailing became more fanciful. The *cheung sam*, either one piece or with jacket, and made in silk or rayon brocade, was reserved mainly for special occasions. The style was never everyday wear for the farming or fishing women as it is too restricting, but

occasionally black gummed silk was used by them for special events.

The skirt

The traditional skirt worn by Chinese women during the Qing dynasty comprised a pair of pleated or gored aprons with panels back and front wrapping around the body, and attached to a wide waistband which was then secured with ties or loops and buttons. Although this style of skirt originated with nomadic tribes, it was worn only by Han Chinese women and not by Manchu women. It was seen as a symbol of maturity as, after marriage, it was worn only on formal occasions; it was never worn alone, but always over trousers or leggings.

The skirt was worn together with a knee-length jacket, the skirt panels being embroidered up to the place where the jacket met the skirt. Back and front panels were identical and edged in braid; narrow pleats to the left side of the panels, or five or twelve godets widening towards the hem, gave ease of movement. The waistband was made of cotton or hemp, and was never in the same material as the skirt which was usually of silk; this was to prevent the skirt from slipping down. The colour was also different from the main body part, being blue, black, white or red. Skirt colours varied: lighter colours were preferred by younger women, blue or black ground colours were worn by older women, and red was worn at weddings and on festive occasions.

With the shortening of the jacket at the beginning of the 1920s the skirt became plainer and hem lengths rose gradually. By the middle of the decade hems had reached mid calf, and the skirt had lost its pleats and decoration to become like Western skirts of the same period. For middle-

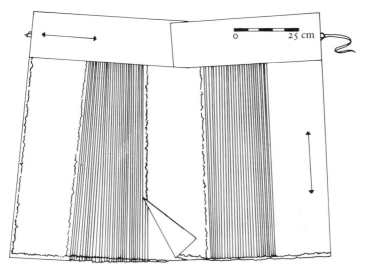

0 25 cm

10. Woman's skirt made of black gummed silk with blue cotton waistband, Hong Kong, mid-twentieth century

and upper-class women fitted two-piece suits and the *cheung sam* became the official garments for formal wear.

For women living and working in the rural areas the skirt was not a practical item of clothing. However, many women possessed at least one which was made as part of their wedding dowry, together with matching *sam* and *fu*. These skirts resembled those of the Qing dynasty in cut and style, but they were always devoid of decoration, with just a narrow braid edging on the panels and hem. Fabrics were homespun hemp, cotton or black gummed silk, and the colour was usually blue or black (Figure 10).

Footwear

Of all the styles of Chinese footwear, none roused as much curiosity and caused as much controversy as the shoes

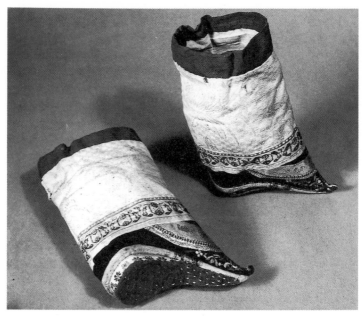

11. Shoes for bound feet, nineteenth century (Source: Horniman Museum, London)

worn by women with bound feet. Lotus hooks, golden lilies and golden lotus were some of the euphemisms for bound feet and, by extension, for the tiny shoes worn (Figure 11).

The cult of foot-binding is thought to have begun in the tenth century, sometime in the years between the end of the Tang dynasty and the beginning of the Song. One of the rulers in this period of five short-lived dynasties was Li Yu, and tradition has it that his favourite consort, Yao-niang, had, for a dance performed for him, bound her feet to suggest a new moon. The fashion caught on among the women at court, but after the Song dynasty the binding became so tight that it was impossible for women with

bound feet to dance. Gradually the style spread to women outside court circles until it was almost universal in China. The Manchus, on coming to power in 1644, tried to ban it and their women never wore the tiny shoes.

Foot-binding was not adopted by Hakka women or the poorest Chinese women who worked in the fields or lived on the water. But in other social circles the custom continued, and it was not until the end of the nineteenth century that, due to Western influence, it began to decline. Various anti-foot-binding societies were established. The new Republic formally banned foot-binding in 1912, and the custom finally died out in the 1930s.

A girl would have her feet bound between the ages of three and five. A binding cloth of finely woven cotton or silk, in black or white and about 180 centimetres long and 7 centimetres wide, was wrapped around the foot, starting at the toes and finishing at the heel. The feet were usually bound to a length of 13 centimetres (5 inches or 3.4 Chinese inches); the '3-inch lotus' being the ideal which could occasionally be attained only among those women who did no work and who had servants to support them while walking.

As part of her dowry a girl would make between four and sixteen pairs of shoes, as proof of her skill in needlework as well as of her small feet. After the wedding a pair was given to each of the main female in-laws. Black was a popular colour for shoes but green and red were worn on special occasions, and especially at weddings; white was worn at funerals. Sleeping shoes of red satin were worn in bed, and women often wished to be buried in them. All the shoes were richly embroidered and had high or low heels, the former being slightly easier to walk in.

Over the bindings of the feet, linen, cotton or silk socks were worn. The soles were reinforced with stitching, and

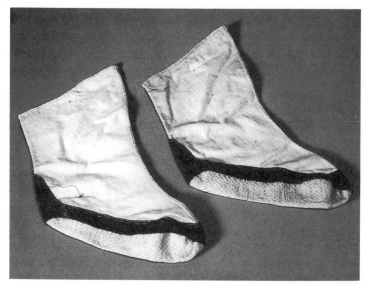

12. Men's white cotton socks with blue uppers, the soles reinforced with stitching, nineteenth century (Source: Horniman Museum, London)

the upper part of the sock flared out above the ankle to make it easier to put on, as the woven material did not allow for any stretching. Seams at the back and front were sometimes covered with rich embroidery and the tops of the socks were held in place around the ankle with ribbons.

Men's stockings were longer, like spats, with uppers and no soles, and were made of white cotton or linen, lined and padded with rows of stitching from top to toe. They opened down the back and the top was edged with a black or blue border. Socks, similar in style to those worn by women, were worn in summer with black cloth shoes (Figure 12).

A wealthy man, especially if he had reached the rank of mandarin, that is, any of the nine superior ranks of the

civil or military service, wore black satin boots. These were made with the leg part longer than was necessary so that it lay in folds around the ankle. Leather piping reinforced the front and back seams; the soles, 7 centimetres thick, were made of layers of felted paper and whitened round the edges.

Black cloth shoes were the most common form of footwear for both men and women of the working classes. Indeed, a proverb of the time runs: 'A man in boots will not speak to a man in shoes' (Sirr, 1849). Like the boots, the shoes had a stiff sole whose thickness was between 3 and 7 centimetres, made of layers of paper (torn, it is said, from the many Bibles distributed in China), or, amongst the poorer people, of old cotton rags. There were two main styles for men, one with a pointed toe curving back round to the sole, and the other with a wide toe the same width as the heel. In both styles the sole was shorter than the upper in order to give sufficient spring for walking, as the sole was quite flat and inflexible. The shoes for the two feet were interchangeable.

The uppers on men's shoes were of black satin, cotton or velvet, plain or appliquéd. Summer shoes were of the same shape but with uppers made of woven palm leaves, and soles of embroidered straw with padded cotton or leather at the bottom. Leather was not used to make the whole shoe, but only for the trimming or binding.

The uppers of women's shoes had colourful embroidery on them; the soles were about 3 centimetres thick and, like those of men's shoes, were painted white around the edges. These were the shoes worn by women who had to work for a living. A more recent style was plain uppers of black cotton or velvet with white cotton linings, and soles made of plastic. Women's shoes fastened with a strap and button across the instep, while men's were pull-on,

in a shape similar to the pointed upper of the previous century.

Another style of shoe popular with Chinese women, from the 1920s to the Second World War, was the beaded slipper. With no heel or back, the slipper had toe caps made of buckram or velvet, covered with tiny bugle beads. The women who embroidered these toe caps tried to incorporate as many beads as possible into a variety of floral designs. They would then take them to a shoemaker to fashion into slippers by adding a sole of thin leather.

About half the working classes wore no shoes at all, and even today some go barefoot when working in the fields. Of the remainder, most wore sandals made of rice straw, wheat straw or rushes, as these prevented the wearer from slipping on the mud during the wet weather; these sandals are called *cho hai*. There were different qualities of straw sandals, from those of rough rice straw costing a few cents, to the rather more costly kind made of rushes or willow straw. In the nineteenth century wealthier men wore a flat mule with square toes, made of plaited rushes in a decorative pattern (Figure 13). Coolies wore rice straw sandals which tied round the ankle, and which can still be found on sale in the market towns in Hong Kong today. Women wore a kind of hemp rope sandal with loops for the toes which slipped on and off easily. None of the sandals lasted long, but all were inexpensive and easily replaced.

Wooden sandals or clogs were worn by men who worked in the fish markets in the New Territories of Hong Kong, or in similar wet conditions. These were crudely fashioned from a block of wood, about 5 centimetres thick, with an upper foot strap made of rubber. An earlier version worn by villagers and labouring classes, dating back to the nineteenth century, was a kind of backless shoe

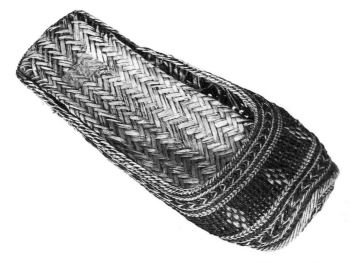

13. Man's rush slipper, Hong Kong, 1868 (Source: Horniman Museum, London)

with a wooden sole and leather upper made from ox or buffalo hide. There were two styles: one had a wooden block under the toe and another under the heel, while the other style had a wooden heel and a thick wooden sole which tapered towards the toe. Both styles had slightly pointed toes, right and left feet were interchangeable, and the backless uppers made the shoes easy to slip on and off.

After the Second World War, especially for their weddings, young girls in rural areas wore a wooden sandal, shaped like a mule but with a slightly raised heel. The sole was carved from wood and had a design of flowers and birds painted on it and then varnished, while the upper strap was of brightly coloured plastic, usually in red or pink.

3
Children's Wear

APART from accessories such as hats, baby carriers and shoes, Chinese children's clothing was tailored on the same lines as that of their parents: the *sam*, *cheung sam*, jacket and *fu* were all miniature versions of the adult styles. Cotton was used for everyday wear, with richly embroidered silks and satins for special occasions. Colours were bright, with a predominance of red and pink as these were considered lucky colours.

Designs on children's wear were all symbolic, and each flower, fruit and creature represented a wish for protection from evil spirits. The three most popular mythological figures, Fuk, Luk and Sau, denoting good fortune, an abundance of good things, and long life respectively, were depicted on many articles of clothing (see cover).

The end of the first month after the birth of a child was an occasion for a celebration, and red eggs would be distributed to well-wishers who would in turn be expected to give a small gift to the child. Sets of clothing comprising jacket or waistcoat, *sam*, divided trousers, navel cover and hat would be presented by the maternal grandmother to replace the swaddling clothes in which the baby had been wrapped since birth.

Underwear for a child consisted of the navel cover, or small triangular apron, which fastened with tapes round the neck and waist. Indeed, this apron was often the only form of clothing worn by a child until it was three or four years old. Divided trousers, as underwear and outerwear, were also common for young children. They date back hundreds of years and are illustrated in a fifteenth-century

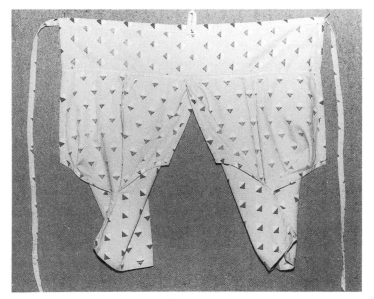

14. Child's divided trousers, Guangdong, 1978

illustrated Chinese primer, first published in 1436 (Good-
rich, 1975). The trousers were made of two pieces of cloth
pleated into a broad waistband (Figure 14), and were
joined only from ankle to knee, leaving open the area
covering the buttocks.

Collars were worn by very young children. These were
divided into several segments, five, six or seven being
the most common, although some were elaborately sub-
divided into many smaller sections, and each segment was
decorated with auspicious symbols. Most collars worn by
children in rural areas were much simpler, serving more
for protection, rather like a bib. Some were made of seg-
ments of different cotton prints and others were of a single
circle. Until recently, Hoklo children wore very elaborate

collars on special occasions and festivals, together with fancy caps and crowns. The collars were made of a circular piece of cotton with a back opening, and decorated with beads, sequins, braid, coloured cotton appliqué and beaded tassels hanging all round the edge (Plates 2 and 5). These were made by the mother or bought from a local embroiderer, and worn by the child up to the age of six or seven. The rest of the outfit was always brightly coloured in pink, red, orange or yellow.

A popular tradition during the nineteenth century was that of making the child a 'hundred families coat'. It was the custom to request small pieces of cloth from neighbours and friends, and then sew these together to make a jacket; thus all those who contributed joined in wishing the child good fortune and protection from evil. A similar custom was the 'hundred families tassel' which was made up of many threads gathered in like fashion, and then pinned to the child's clothes.

Waistcoats were worn by older children, and these would be colourfully embroidered and edged with braid. Loops and buttons fastened the front to the back of the waistcoat, at the neck and down the right side, while a centre loop hooked over the button on the *cheung sam* or jacket underneath. Older boys wore a blue sleeveless satin waistcoat called a *pui sum* over their *cheung sam* at Chinese New Year and on special occasions.

Children's hats

Charms and symbols, frequently used by Chinese people of all ages, were particularly important for children to protect them from harm. Elaborately decorated hats, often in the form of a fierce animal which would scare away evil spirits, were worn by the child with this end in mind. Un-

til the end of the nineteenth century only boys would wear these hats as girls were considered of little importance.

Hats were still made and worn until very recently, especially among the more traditional boat people. A mother would make one for her child or, if she did not have the necessary skill, buy it from a neighbour or relative. These caps could be seen especially at fishing festivals, when children were dressed in all their finery, and in the cold winter months around Chinese New Year.

There were several different kinds of children's hats. The first, made from a strip of red satin or cotton gathered into a circle at the top with a centre back seam, was embroidered with designs of flowers, fruit, and Chinese characters wishing the child long life and good fortune (Plate 3). It was worn from the age of one month, when it would be presented to the child by the mother or grandmother.

The second kind was similar to the first, but the top of the crown was completely open. It often took the form of an animal such as a tiger, dog or pig, with a face at the front and a padded tail at the back. A similar style seen more frequently in Hong Kong and worn until fairly recently by Hoklo children at the first month celebration and then on other special occasions, consisted of a strip of material joined at the back and slightly gathered along the top edge. Above the ears and at the centre front were pleated fabric rosettes, and braid and beads decorated the edges. The whole effect was very colourful, some hats even having little animals and charms on wire which danced in the breeze.

When a child was about one year old it would wear the 'dog's head cap'. This was made of black or red cotton, plain or patterned, with a seam running from centre front to centre back. A horizontal cut about a third of the way

up from the front was folded down to give the impression of dog's ears. The edges were bound with contrasting cotton, and the ears would sometimes have little tufts of fur to further suggest the animal. Some hats made around forty years ago for slightly older children had decoration in the form of embroidered and appliquéd birds and bats: additional help for the dog in his fight against evil. On the whole, however, this was a plain style which was worn more for warmth than decoration. A further development was the dog's head cap with a back flap added, the purpose of which was to cover the back of the neck in cold weather. The crown was made separately from the brim, with the cut all the way round the head.

Another style of winter hat was the 'wind hat'. It was shaped like the dog's head cap, or with the crown gathered into a circle like a skull cap, the back flap being part of the hat and not an additional piece. Wind hats were often lined and padded, some being embroidered with flowers and birds, while others had a fierce animal face. Loops at the sides had tapes attached to them to anchor the hat under the chin, and long streamers hung down the back with bells at the ends.

Another variation of the wind hat was a close-fitting round hat, the flap of which had a scalloped edge. The crown of the hat was circular, and had a horizontal cut all round, with the centre gathered together or cut out. Imitation ear flaps were caught up and tied back with long streamers, and an embroidered band was placed along the brim at the front. Until very recently Hoklo children wore this style of hat, made of black cotton with modern embroidered designs of planes and junks, as well as insects and birds (Plate 4).

A hat given to an older child was the 'scholar' or 'tile cap', so called because of its flat sloping crown like the roof

of a house. This hat was given to a male child in the hope that he would do well in the official examinations, and thus bring honour and glory to his clan. Made of black satin, it was embroidered with bats, flowers, and religious symbols. At the back were often two streamers and two pointed 'feathers'.

A style of hat more like a crown was worn by Hoklo children at their festivals and Chinese New Year, up to the age of six. The crown was made of stiffened card covered with fabric and decorated with embroidery, sequins and chains, with streamers hanging down the back. Tassels hung from the sides, and silk puff balls and stuffed toy animals and birds were attached to wire springs to make them quiver when the child moved (Plate 5). The crown was usually worn with the decorative collar which was trimmed in the same way with braid, sequins and beads.

The final style, still seen occasionally at Chinese New Year, is the stiffened black satin skull cap topped with a black or red button or pompom. The cap was made from six segments fixed to a narrow brim. Only boys wore this style, and before the Second World War they wore an un-stiffened flatter version until they grew to manhood.

Baby carriers

Carrying a baby on the mother's back has been the custom for centuries in China, and it is still seen today both in China and in Hong Kong. For any mother who had by necessity to work in the fields, on the boat, or round the home, it was a safe and convenient way to keep a child out of mischief. As more babies were born to the family, it was the turn of the older girls to carry the younger siblings on their backs.

The baby carrier is made from a square of cloth, usually

decorated with embroidery, with four long strips of fabric at each corner of the square which tie in a knot in front of the wearer, enabling the child to be carried with ease. It was the custom for the grandmother to provide the carrier when the child was one month old. In the past carriers were made by hand by the donor, or else purchased from an embroiderer, but nowadays they are usually bought from a market stall.

At the top centre of the decorated square is a triangle of folded cloth. Originally it was five layers thick, to represent the five blessings; later it was reduced to one thickness and is a wish for good luck and many children. One superstition holds that the carrier must never be used the wrong side out, unless one parent is dead, in which case it must be worn that way.

There were three main types of carrier. The first, still popular in Hong Kong today, was a square with a decorated centre piece and straps which were extensions of the top and bottom edges. Earlier carriers of this style, dating back to the nineteenth century, were quite large, being 50 to 60 centimetres square with straps extending a further 110 centimetres. At the end of one or both lower straps the corners would be folded over to the centre to form a pocket in which to carry money. The centres of the carriers were usually of red or pink satin, cotton or wool, sometimes embroidered and sometimes left plain. At the top centre was a triangular charm of several thicknesses, and at each side of the centre square were placed pieces of fabric in lighter colours. The straps were made of cotton or hemp dyed purplish black or indigo blue, and were attached to the carrier with reinforcing stitches on the joins. Modern versions of this style are smaller and simpler in construction, and usually made of red or patterned cotton with an embroidered centre square. However, those made

for presentation on a special occasion would be made of red satin or gold brocade.

A second shape seen more often in rural areas has the centre square slightly smaller than that of the previous version: about 35 centimetres square, but with longer straps. These straps are fixed diagonally to the four corners of the square, with much reinforcing stitching at these points. This style was especially popular with Hoklo women who still make their own from a large variety of patterned and plain cottons.

Head supports were attached to both these styles. These were made either of strips of cotton stitched at intervals to form a square, or of a plain piece of cloth, and were attached to the top edge of the carrier to support the baby's head, and to shield it from the sun (Plate 6).

The third style was the simplest of all and consisted of a plain, undecorated strip of red cotton or hemp, approximately 310 centimetres long by 30 centimetres wide. Originally worn by the groom on his wedding day some decades ago, this plain strip was still used until recently by boatwomen to carry their babies. The material was wound twice round the child, and then tied in a knot in front of the wearer (Plate 7).

The designs on the centres of the carriers were a plethora of good luck symbols. The most common were a pair of mandarin ducks, pomegranates, lotus flowers and butterflies, as well as the characters for 'double happiness', 'long life' and 'good fortune'. In addition to embroidered cotton or rayon, the centres were made up in many other ways, such as woven pictures, crochet pictures, white canvas squares with red cross stitch, and interwoven strips of cotton.

Baby carriers made by Hoklo women were the most interesting and elaborate: of many different fabrics and

colours, they resembled the hundred family coats of the nineteenth century. Folded strips and triangles of cotton fill the centre square and continue up the top straps, so that when tied in front, the decoration is visible as far as the knot (Plate 8). Special carriers worn at festivals had bells (to frighten off the bad spirits), tassels, fringing, beading and appliqué in all the colours of the rainbow.

Equally decorative were the baby carrier covers made by Hoklo women to protect the child on special occasions and in the cold season. Embellished like the carriers with embroidery, appliqué, braid, tassels and bells, they are real works of art which took many months to complete (Plate 9). Simpler covers, made of two layers of brightly patterned cotton stitched together so as to be reversible, were used by other ethnic groups. The layers of cotton were pleated into a smaller band at the top, and two sets of ties held the cover in place around the child. More decorative covers with fur lining and hoods were sold as gift sets at Chinese New Year.

Children's footwear

Like their hats, children's footwear was another article of clothing often made in the form of a dog, cat, tiger, or pig for the purpose of frightening away bad spirits. Large eyes to see evil lurking, large furry ears to hear it, and whiskers all helped to suggest the creature represented. Usually made of red cotton or satin, with brightly embroidered uppers and padded cotton soles, some shoes even had bells on the toes to produce an audible warning for the spirits.

Very young children would wear satin bootees when carried in their baby carrier on special occasions. Viewed from the front these were most colourful, made of red, orange or purple satin embroidered with designs of the

dragon, phoenix, fish or deer, while often padded animals and birds were suspended above the toe on wires. Long coloured tassels hung from the front, together with multi-coloured bobbles which are typical of south Chinese decoration.

As with children's clothing, footwear for older children was like a miniature version of their parents', albeit more colourful. Made of cotton, with cotton or thin leather soles, shoes were embroidered with propitious symbols such as bats, coins, flowers, butterflies, and the character for 'long life'.

4
Wedding Customs and Dress

A Chinese marriage ceremony was a matter of utmost seriousness, not only for the bride and groom, but also for their immediate families and for the villages in which they lived. The union was seen as a means of maintaining good ties with another village and of establishing a firm bond between them. The marriage was always an arranged one, with a matchmaker being called upon to consult horoscopes in an effort to find the boy a suitable mate, and it was likely that the pair had never seen each other before the wedding day.

A wedding in the nineteenth century would have been a most elaborate affair. An auspicious day was chosen according to the Chinese almanac, and the question of dowry and other gifts settled. It was the custom in some areas for the bridegroom's family to send to the bride 'a girdle, a headdress, a silken covering for the head and face, and several articles of ready made clothing, which are usually borrowed or rented for the occasion. These are to be worn by the bride on entering the bridal sedan to be carried to the home of her husband on the morning of her marriage' (Doolittle, 1865).

The day before the wedding the bride would have the hairs on her forehead removed with two red threads to give a more open-faced look; the process was called *hoi min*, literally 'opening the face'. This was done by a fortunate woman with many sons, so that the bride too would be similarly blessed. Her hair was then styled in the manner of the married women in her social class.

On the appointed day the bride left her village in a richly

decorated sedan chair, closed and hidden from view. She would be dressed in an embroidered skirt with a long black or red silk jacket, and around her neck might be a large elaborately decorated detachable collar. On her head would be an ornate headdress made of gilded silver inlaid with kingfisher feathers and embellished with pearls, and over this a large red veil which would totally obscure her features. Red had been a favourite colour since the Ming dynasty as it was considered to be lucky.

The groom's wedding attire was simpler than the bride's. A centre-opening black coat, sometimes with badges of rank fixed to front and back, was worn over an embroidered dragon robe if the man held an important position, or over a blue *cheung sam* if he did not. A long red cotton sash was draped over one shoulder and tied at the waist; this sash would later be used as a baby carrier. On his head was a black hat with red tassels, and the button showing his rank as mandarin if he had such status.

The number of clothes worn by the bride and groom was important. The bride had to wear four or six items: two items of white underwear, two black garments, and a jacket and skirt, while the groom wore three or five garments: two items of underwear, *fu, cheung sam* and jacket. These numbers conformed to the *yin* and *yang* principles, with even numbers for female (*yin*) and odd numbers for male (*yang*).

When the wedding procession arrived at the groom's home, the groom would knock on the door of the chair with his fan; the bride then stepped out and the groom raised the red veil. Firecrackers were set off and the bride was lifted on the back of a female servant over a charcoal fire, while above her head was carried a tray containing items such as chopsticks and rice. Being carried over fire was said to purify the bride from any contamination she

might have encountered on the journey. An umbrella was also often held over her by an older woman to prevent bad luck from falling upon her, a custom which can still be seen today.

After prostrating themselves before the altar, the couple were escorted to the bridal chamber where they were given tea and cakes. 'The bride tries hard at this time to get a piece of her husband's gown under her when she sits down, for, if she does, it will ensure her having the upper hand of him, while he tries to prevent her and to do the same himself with her dress. The strings of pearls on her coronet are now drawn aside by the maids in attendance, in order that the bridegroom may have an opportunity of seeing the features of his bride. . .' (Ball, 1925). The bride then kowtowed to her new in-laws and offered them a cup of tea. Following a feast, friends and relatives made personal remarks at the bride's expense, often late into the night. On the third day the ancestors were worshipped again, and the couple would pay a visit to the bride's parents. After this there would be little communication between the bride and her family, as she was then considered to belong to her husband's family.

Until the middle of the twentieth century the actual ceremony had not changed much, although by then it was usual for the groom to wear the *cheung sam* and *ma kwa* which had become male formal attire after the founding of the Republic. The bride's jacket was very richly decorated to match the skirt and was usually red in colour, although black jackets enjoyed a spell of popularity during the 1950s and early 1960s. The wedding jacket and skirt were richly decorated with the dragon and phoenix: these were originally intended to symbolize the emperor and empress of China and to emphasize the relationship between the imperial family and its subjects. This outfit was called a *hung*

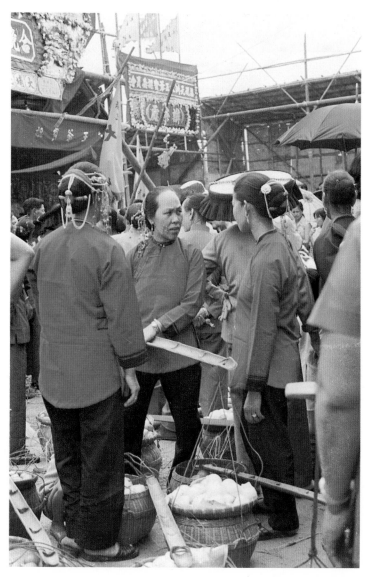

1. Hoklo women celebrating Dai Wong Yeh festival, Tai Po, Hong Kong, 1979

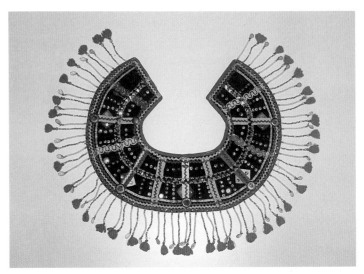

2. Hoklo child's beaded collar worn at festivals, Sai Kung, Hong Kong, 1979

3. Baby's cap worn from age of one month embroidered with 'long life' character at centre front, Hong Kong, early twentieth century

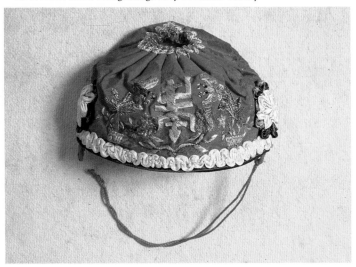

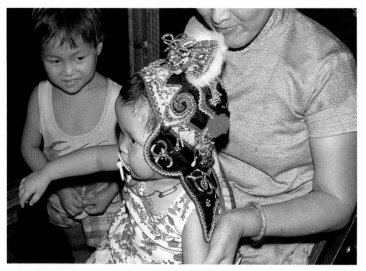

4. Wind hat worn by Hoklo child, Sha Tau Kok, Hong Kong, 1979

5. Hoklo child dressed in embroidered collar and sash for Dai Wong Yeh festival and grandmother holding child's crown, Tai Po, Hong Kong, 1979

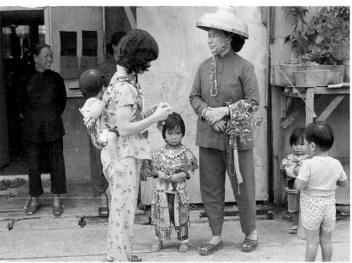

7. Hoklo red cotton baby carrier, Tai Po, Hong Kong, 1979

6. Hoklo baby carrier worn at Dai Wong Yeh festival, Tai Po, Hong Kong, 1979

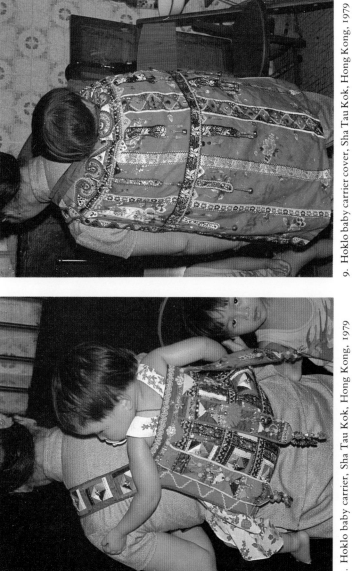

8. Hoklo baby carrier, Sha Tau Kok, Hong Kong, 1979

9. Hoklo baby carrier cover, Sha Tau Kok, Hong Kong, 1979

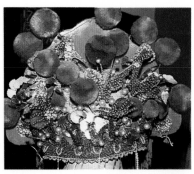

10. Bridal headdress, Tai Po, Hong Kong, mid twentieth century

11. Hakka wedding, Sai Kung, Hong Kong, 1979

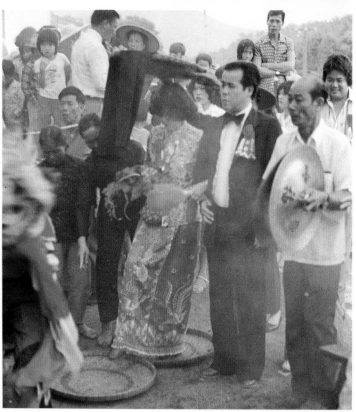

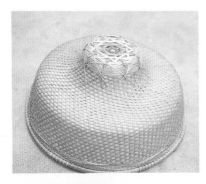

12. Tanka straw hat decorated with a woven star, Tai Po, Hong Kong, 1979

13. Punti headband, Yuen Long, Hong Kong, 1979

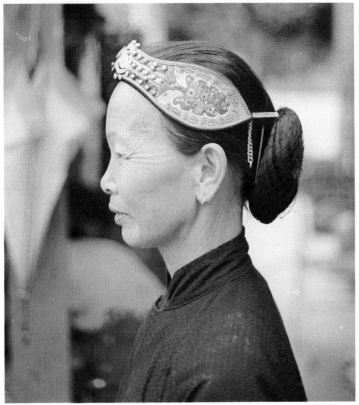

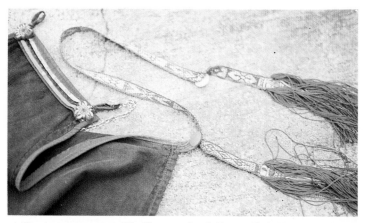

14. Punti summer apron with silk woven band, Sheung Shui, Hong Kong, 1979

15. Hakka winter apron, Tai Po, Hong Kong, 1979

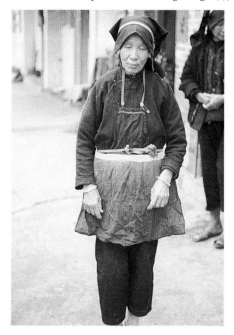

kwa, and the origin of it is said to go back to the Yuan dynasty, when it could be worn only by women from the imperial family. However, so the story goes, when a courtier was seen by the Khan to be packing up old clothes to give to his sister for her wedding, the Khan took pity on the girl and ordered that she be given a *kwa* which had belonged to the imperial family. From then on brides who were not members of the imperial family could wear the *kwa*.

The wedding attire of a country bride in the New Territories of Hong Kong was more subdued. A typical outfit from the 1940s comprised a purplish black locally dyed cotton *sam* (Figure 3), a pair of matching *fu* with four seams, and over this a matching cotton skirt with six pleats each side of the front, with the same arrangement at the back. These three garments would be made by the bride herself. On each ankle was a heavy silver bangle, and on her head an ornate headdress sometimes worn together with a richly decorated collar. These items could be rented from shops specializing in wedding paraphernalia, but they were often purchased by the bride who would then put them away safely after her wedding day, to be brought out again years later and worn on the major birthdays, and she would be buried in them.

The headdress, which was intended to resemble an empress's crown, was made of a kind of plaster of Paris or cloth-covered card, stuck to which were beads and sequined motifs in the form of butterflies, flowers and the phoenix (the symbol of the empress of China). Colourful puff balls, a feature typical of south China, quivered on wires, pink or red tassels hung at each side, and rows of pearls hung over the front to cover the face, while at the back was a flap with more sequined decoration and tassels (Plate 10). The collar, which was made of red satin

adorned with sequins and braid, was pointed at front and back and decorated round the edge with coloured tassels.

By the mid-1960s outside influences had begun to alter the look of the traditional wedding attire and a bride in the urban areas of Hong Kong could be seen wearing a Western-style white wedding dress at the Registry Office ceremony while the groom wore a dinner jacket and white dress shirt. But the traditional *kwa* in red, decorated with gold and silver embroidery, was still worn for kowtowing to the ancestors and both sets of parents, and for the banquet in the evening. Many shops in Hong Kong still supply the *kwa* which is so expensive to buy that it is usually hired. The style of the skirt is similar to those from the early years of this century, with two panels back and front, pleats at the sides, either real or suggested, plus a red fringe at the hem (Plate 11). The jacket is close fitting with a high collar, long sleeves and the centre front fastens with snaps. In certain areas in Hong Kong tailors can be seen designing and embroidering panels or assembling panels which have been imported from China already embroidered.

Make-up, applied by a specialist in wedding make-up, has always been an important part of getting married. The bride would have her face made up twice: once before the ceremony, and again before the banquet at night. The make-up was applied quite heavily by normal standards in order to complement the ornate decoration on the clothes, and the gold jewellery in the form of large ornate necklaces and bangles, with long life, double happiness and dragon and phoenix symbols on them. Until recently at some country weddings, especially around Sha Tau Kok, a small convex metal disk (*chiu yiu king*, literally 'demon-deflecting mirror') which had been highly polished to resemble a mirror, was worn by the bride around her neck

to frighten away bad spirits. The bride also wore a red bag round her neck in which to put the *laisee* packets she was given, and she carried a pink feather fan. Red shoes completed her outfit: embroidered cloth slippers were worn by town brides, and painted wooden sandals by country brides, while custom dictated that the bride should change her shoes after worshipping the ancestors to signify a new start in life.

5
Funeral Rites and Clothing

PREPARATION for the life hereafter was, and still is, very important to the Chinese people. In addition, worship of one's ancestors with strict adherence to traditional funeral rites goes a long way in providing for an improved existence for them in the spiritual world, as well as for oneself in this world.

The style of clothing worn by the bride and groom at their wedding was closely related to that worn for their burial. In fact, if the wearer had been fortunate enough to own items such as the headdress and gown these would then have been stored carefully in a dowry chest after the wedding ceremony to be worn at the next important milestone, that of the sixtieth birthday, and on subsequent occasions until the owner would finally be buried in them.

The sixtieth birthday marked the time when a Chinese person would start to make preparations for his or her burial, in particular the outfit in which he or she was to be buried. Clothing for the dead was either made to measure or purchased ready made from shops specializing in it. Ready-made clothes for poorer people were often pasted together of the cheapest satin or even paper, but richer people had the outfit made to measure from cotton or silk.

As at the wedding the number of clothes worn was very important: 'It is an established custom that, if three garments are put on the lower part of the person, five must be put on the upper part. The rule is that *there must be two more upon the upper than upon the lower part of the corpse.* Oftentimes there are nine upon the upper and seven upon the lower. Sometimes rich families provide as high as twenty-

one pieces for the upper part of the corpse, and nineteen for the lower part' (Doolittle, 1865). For women, as a rule, there were six pieces on the upper part and four on the lower.

In the mid-twentieth century the burial clothing for a man would be the *ma kwa* worn over *cheung sam* and trousers which were padded; with this he would wear a felt hat, white silk socks and black cloth shoes. Buried with them would be a handkerchief, a white paper folding fan and a walking stick, and a silver coin would be placed in the mouth to pay the spirits in the next world. Alternatively a man might be buried wearing a copy of a mandarin's hat with red fringing and a wooden centre ornament, or a Daoist priest's headdress with the *yin yang* symbol on it. If a man had held an important position in life, he would have stitched to the front and back of his robe an embroidered square. This was a custom dating back to the Qing dynasty when mandarins and their wives were buried with their badges of rank fixed to their robes. Squares made in recent years were crudely embroidered and the birds depicted symbolized no particular rank.

A woman would be buried in a long gown under which would be the *sam, fu* and skirt. On her head would be the headdress she had worn at her wedding, or a cardboard replica, and on her feet were red shoes and white socks. Also with her was a mirror, comb, handkerchief, patterned fan and silver coin.

There were certain superstitions attached to the choice of clothing. Brass buttons were never used for fastening as they would weight the body to the earth, and in general buttons were avoided as the phrase for doing up a button (*kau niu*) was similar in sound to that meaning 'to detain somebody against his will'. Burial clothing is euphemistically called *sau yee* (long-life garment) rather than a more

literal expression for clothing for the dead, as it is considered more fortuitous. Finally, no fur was used on the clothing lest the deceased be reborn into the body of an animal.

During the nineteenth century the rituals surrounding death and mourning were strict. A man was required to wear mourning dress for those superior, or equal in status, to himself; this naturally excluded his wife and children whose funeral he did not attend, although some affectionate husbands adopted a modified version for their wives. Elders of the deceased observed no obligatory mourning period, but a father would mourn his eldest son.

There were five grades of mourning costume, known as *ng fuk*. The first, and most important, was for parents. A dress of undyed, unhemmed coarse hemp was worn, together with a headdress of hemp, straw sandals and mourning staff. The wearing of hemp in this unfinished state symbolized the greatest manifestation of poverty by the son, and represented the traditional idea of giving all one's possessions to the deceased to ensure him a comfortable life in the next world. The mourning for parents lasted twenty-seven months. The second grade of mourning was for grandparents and great-grandparents, for whom the mourning period was one year. The mourning dress was of undyed, hemmed coarse hemp, with a hemp headdress, shoes and bamboo mourning staff. The third grade was for brothers and sisters, and a dress of coarse hemp was worn for nine months. A fourth grade, lasting for five months, was for aunts and uncles and consisted of a dress of medium coarse hemp. The final grade for distant relatives lasted for three months, and finished hemp was worn.

In the nineteenth century men in mourning for their parents had to relinquish public office for a period of time

and rites were performed every seventh day after the death for forty-nine days. After the rites had been performed for the third time on the twenty-first day the hemp was exchanged for sombre clothes, and towards the end of mourning silk could be worn, but shoes had to be of blue cloth. White clothes, shoes, cap button and cord in the queue were usually worn immediately after the hemp, and thereafter blue clothes, shoes, cap button and cord in the queue.

As time went by the period of conspicuous mourning became much shorter and there were only two grades of mourning clothes: undyed coarse hemp for close relatives, and undyed fine hemp for others. After the funeral ceremony wool flowers were worn in the hair by the female mourners: white flowers for parents or husband, blue for grandparents, and green for great-grandparents. After one hundred days a pink wool flower was worn for the last three days to show that mourning was nearly over. Men wore a small piece of black ribbon fastened to an upper garment, and their period of mourning was six weeks. The wearing of wool flowers by women and black ribbon by men is known as *daai hau*, literally 'wearing filial piety'.

6
Rural Clothing

In addition to basic clothing such as the *sam fu*, certain items of apparel were worn by each of the four ethnic groups (Punti, Hakka, Hoklo and Tanka) living in the rural areas of Hong Kong and Guangdong province which were often peculiar to their occupation as well as serving to distinguish them from the other groups.

Headwear

The conical or domed hat made of bamboo splints and leaves was a common sight throughout southern China. It was worn by Punti farmers and labourers, both men and women, as protection from the rain and sun (Figure 15). A similar style was worn by Hoklo women but this had a woven strip of bamboo on the inside of the crown to raise it off the head, a refinement necessitated by their elaborate hair-styles.

The Hakka 'cool hat' (*leung mo*) is still well known. It is a flat circle of woven straw with a hole in the centre and a black cotton fringe around the edge, and is worn only by women when working out of doors for its protection from flies and the elements (Figure 16). It is sometimes worn by Punti women and occasionally by Hoklo women who put a circular band of straw inside to raise it off the head.

There are two or three variations of straw weave depending on where the hats are made, and sometimes blue fringing is used in place of the black. The centre hole is bound with bias strips of black cotton or hemp, and the fringe is pleated and sewn to the outer edge of the hat. In

48

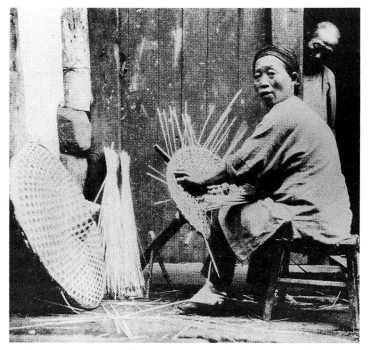

15. Cantonese hat made of bamboo splints and leaves, Guangdong, *c.* 1925
(Source: Franck, 1925)

wet weather a black or blue plastic hood is worn over the
hat with the fringe tucked inside. (Older Hoklo women
wear it this way in dry weather.) A patterned band is fixed
to the top of the hat and fastens under the chin. The hat is
often worn over a towel or black headcloth either to pro-
tect the head from the sun, or for extra warmth in winter.

The Tanka hat with its domed crown and turned-down
brim can be seen worn by both men and women in fishing
villages throughout the region. The hats are made in
Guangdong province, some in Jiangmen, 60 kilometres
south of Guangzhou, and some in Yangjiang, 200

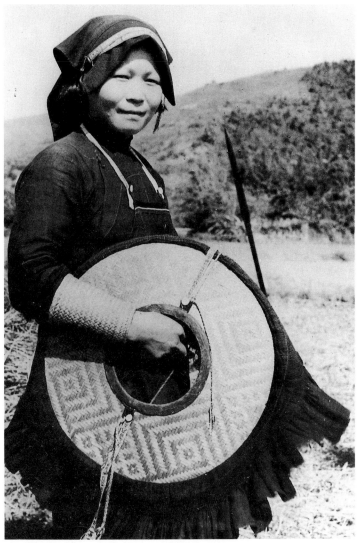

16. Hakka woman wearing headcloth and woven band, apron and wrist-covers, and holding the cool hat, Hong Kong, 1946 (Source: Public Records Office, Hong Kong)

kilometres south-west of Guangzhou, and there are slight
variations in the weave depending on the place of origin.
In the past women would often have the crown of their
hats decorated with coloured plastic cord. This decoration
was in the form of a very elaborately woven star which
covered the whole of the crown, sometimes extending to
the brim. The star was said to bring safety and luck to the
wearer and was made in several bright colours such as
pink, green, red and gold (Plate 12). Inside the crown a
piece of red paper—another lucky charm—was placed
under the straw and the hat was often marked with a
character or stencilled design to assist in identification.

Sometimes the shape of the hat was altered to make it
more attractive. When new, the hat was soaked in water
until the straw became malleable. It was then pressed hard
with a heavy stone until the edges of the crown and brim
were squared off and the hat dried. This procedure was
carried out by women who specialized in both this and the
crown decoration.

An alternative form of headwear was the scarf worn by
the older women in the different ethnic groups. Still seen is
the black *bau tau* (literally 'head wrap') (Figure 16) worn by
Hakka women when at home where the cool hat would be
too cumbersome. Made of plain or dobby weave cotton,
or black gummed silk, it is a simple rectangle with approx-
imately one third of the length turned back to the right
side along a seam, and held in place with a patterned,
woven band.

There are two methods by which the cloth is held in
place. The first, and the more common, is by cotton loops
attached to each corner of the edge to be folded back. The
woven band is then threaded through the loops, taken
under the hair at the back of the head, and both ends of the
band hang across the top of the head with the tassels over

one ear. In the second method matching fabric tapes are attached to the corners of the rectangle to be folded back. The woven band is cut in half and sewn to each tape, then crossed over at the back of the head and brought separately over the top, with the tassels tucked out of sight at the back. This way was favoured by some women who believed it kept the woven band cleaner.

Older Tanka women who live on land also wore a headscarf, especially in the cooler weather. The usual kind was made of black cotton approximately 72 centimetres square with an embroidered border, in red, or occasionally orange or purple, in an irregular zigzag pattern. The scarf was folded into a triangle and in the folded edge was placed a metal or bamboo band which was covered with paper. The band was flexible and framed the face to protect the eyes from the sun. Another scarf, worn by younger women, was made of brightly checked cotton, often of red and white 'table-cloth' check, with the same embroidered pattern at the edges, but with multi-coloured thread. The method of tying the scarf was the same as for the black scarves, with the corner point on the right side, pointing upwards by the right ear. Both kinds of scarves were made by women for their own use.

Instead of a headcloth, Punti women wore a headband called a *fa lap* during the cooler months. Worn high on the forehead it was fastened at the back with a gold link chain sewn to the band (Plate 13). Only married women wore the *fa lap*, and in the past it was made as part of the wedding outfit. Elaborately embroidered with pearls and gold ornaments, and sometimes with beading and sequins, with a piece of jade at the centre, the headband was usually carefully put away after the wedding to be worn on special occasions, while another slightly wider one, made of plain black satin with narrow coloured piping at the edges, was

worn every day by older women for warmth. Both kinds could be bought in the market towns in the New Territories and the gold ornaments were added by the wearer.

Another type of headband worn by older Punti women was the *wai ngak*. The shape was similar to that of the *fa lap* but the band was always plain, and the women made it themselves from scraps of dark coloured cotton, lightly padded and bound at the edges. This band was purely functional and worn lower than the *fa lap* to cover most of the ears. Older Hakka women had a headband of similar shape and size, which was worn over the *bau tau* for extra warmth. Some of these headbands have a jade, or imitation jade, button fixed to the centre.

Aprons

It was common in the past for Punti and Hakka women to wear an apron of one style in winter and another of a different style in summer, but by the end of the 1970s the summer apron was generally being worn throughout the year.

Made of black or blue cotton, or sometimes black gummed silk, the Hakka summer apron (*wai kwan*) over the past forty years became progressively shorter; very short ones were also worn which offered little protection for the clothing, and were more for decoration. A feature common to most aprons was the two seams, or lines of stitching, a few centimetres inside the outer edges, and running parallel to the centre front. The seams were approximately 36 centimetres apart which corresponded to the width of the hand looms used in the past to make fabric. Even when the aprons were made from wider mass-produced fabrics, the seams or lines of stitching were still retained.

Across the top of the apron were bias-cut bands of cloth

of contrasting or matching material and colour, plus two or three rows of coloured piping, ric-rac braid or fancy stitching. In the past Hakka aprons were elaborately decorated at the top for wearing on special occasions (Burkhardt, 1955–9). Around the neck was a silver chain with silver coins at each end which were threaded through the loops attached to the top of the apron. There were no pockets as there were pockets on the *sam* worn as underwear, and the apron fastened at the waist with a patterned woven band.

The Punti summer apron was of similar shape and fabric, but was a little more colourful. The top decoration was different and consisted of rows of coloured piping made of folded plain or printed cotton, while round the top three edges of the apron was blue or green piping (Plate 14). At the top two corners were ornamental frogs of blue and white or green and white cotton, and the loops of the frogs anchored the silver chain which went around the neck. A silk patterned woven band held the apron at the waist.

Winter aprons were worn by older women, often throughout the year (Plate 15). The skirt part of the Hakka apron was made of brown glazed cotton, while the top was of two layers of black cotton or rayon, with an opening at the side to form a small pocket. The top edge was decorated in similar fashion to the summer apron and was completely reversible. The wide waistband was made of pink and white striped cotton, and a long woven patterned band was attached to the sides, crossed over at the back, and tied in a half bow at the front. A silver chain fastened at the neck.

The winter apron worn by Punti women was more sombre. Made of black cotton, often from an old *sam*, the top was like the Hakka winter apron, but the skirt was

split at the right side for ease of movement. It had no pocket, and was held in place at the neck by a silver chain.

Straw and bamboo clothing

The straw raincoat, or *so yee*, has been worn for centuries by peasants and can still be seen in remote areas of Guangdong province (Figure 17). Made of dried leaves from the palm tree or of rice straw, depending on the region, layers of the leaves or straw were folded and stitched to the layer above with string made from rice straw. Seven layers made up the coat, which was wider at the top to form the sleeves.

Straw aprons were also worn by men and women, especially the latter, when threshing rice. Constructed in similar fashion to the raincoats, and made of four layers of rice straw or palm leaves, they reached from waist to knee, and hung round the neck by a long string made of rice straw. To protect the hands when cutting rice straw or grass, women wore cream canvas mittens bound at the edges with blue cotton. Over these were worn plaited rice straw wrist-covers for extra protection (Figure 16).

Dating back to the Ming dynasty is the bamboo jacket or waistcoat, which was worn in south China up to the beginning of this century. 'Bamboo clothing is made from the finest branches of the tree, worn in summer next to the skin to keep the light cotton shirt or inner jacket from irritating the skin when moist from perspiration...' (Dudgeon, 1885). Made like a large jacket with a centre opening, it was constructed from tiny pieces of hollow bamboo sewn together in a diagonal pattern. A pattern was achieved by omitting one row of bamboo pieces about 10 centimetres up from the edge of the sleeve and from the hem. Around the edges of the neck, sleeves and underarms

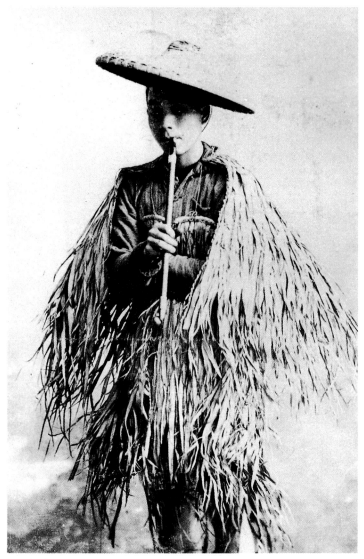

17. Coolie wearing a straw raincoat and straw apron, 1912–19 (Source: Public Records Office, Hong Kong)

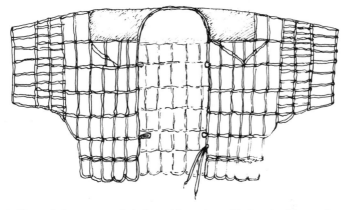

18. Knotted rice straw underjacket with patches of indigo-dyed coarse hemp at shoulders, Sai Kung, Hong Kong, early twentieth century (Source: Urban Council, Hong Kong)

was a cotton binding; the fastening at the neck was a button and loop and at the waist were ties. Some jackets had sleeves and others were sleeveless. Aprons were made in the same way.

The effect of this openwork construction was like that of a modern string vest: it trapped the air and kept the wearer cool and dry during the hot damp summers of southern China. Even closer to a modern string vest was the undergarment worn by peasants (Figure 18). Resembling the bamboo jacket in shape, but fitting more closely to the body, the jacket was made of rice straw twisted into string and knotted together in an open weave design. Again, as with the bamboo jacket, a decorative row outlined the hem of the jacket and the edges of the sleeves. The neck and waist fastened with loops and brass buttons, while the yoke was made of indigo-dyed or natural cotton or hemp in a double layer. This yoke served to prevent soreness on the shoulders when the wearer was carrying heavy loads.

7
Accessories and Charms

ALTHOUGH the basic outfit of *sam fu* or *cheung sam* was simple in cut and pattern, a person could wear many forms of adornment. Some of these items were confined to one ethnic group and not worn by others. Lucky charms for protection against evil were also worn, particularly by children who were thought to be especially vulnerable as they passed through the thirty dangerous barriers of life, from birth up to the age of fifteen.

Amulets

Pressed silver or brass amulets, ranging in size from 1 to 6 centimetres, were frequently arranged across the front of a child's hat. Most popular were the Eight Immortals with the God of Longevity, Sau Shing, in the centre. They are shown together because the Eight Immortals were said to be guests at the annual feast in the Western Heavens for Sau Shing who is usually shown mounted or standing beside a deer, with a peach in one hand and a staff in the other.

Another amulet seen on children's hats was the Pak Kwa, or Eight Trigrams, which was placed in the centre of the hat. This is a mystic symbol showing eight groups of lines arranged in a circle, each group consisting of combinations of broken and unbroken lines, arranged in three ranks, and often having the *yin yang* symbol of creation in the centre. The Trigrams were the basis of the ancient system of divination and philosophy. Wearing such a plaque is said to safeguard the wearer from harm and ensure his continued good fortune. Other plaques fixed to the back

of the hat sported auspicious Chinese characters such as those for 'good luck' and 'long life', as well as religious and mythological figures.

Apron chains

Worn by Punti and Hakka women, silver apron chains had coins fixed at each end which attached through loops at the top of the apron. The chain was about 55 centimetres long, of single links, with coins often dating back to 1900 and before. Also seen in remote parts of the New Territories of Hong Kong were older, more elaborate styles having double chains with coins every five links or so, while others had several coins welded round a centre one to form a flower. These coins were often the old Hong Kong 20-cent piece and the Guangdong 10-cent piece. Other old styles had silver ornaments of flowers and butterflies interspersed along the links, and at each end.

Bangles

Carved silver bangles were worn round the wrist, or around both ankles, by the bride at her wedding. Jade bangles are still very popular today, and are worn by all ages: '. . . a married woman sometimes wears two, one on behalf of her husband [Plate 15]. If the bangle is broken by a blow, it is considered that the jade absorbed the shock which would otherwise have broken the wrist' (Burkhardt, 1955–9).

Bells

Bells were attached to a metal ring worn round a baby's ankle (Plate 7), while large brass bells held to the ankle by

red thread were worn by children in fishing villages. Bells were also attached to baby hats, hoods, covers and carriers. Called *ling tze*, bells were intended to scare off bad spirits with their noise.

Coins

Old coins from past dynasties were a favourite charm as they were thought to have powers of protection. The coins were often threaded in the form of a sword and hung at the head of the sick bed to aid recovery.

Coins were also a charm for children and hung on red cord round the child's neck. The number of cash (the name given to small denominations of coins) was equal to the number of years the child had lived, up to the age of fifteen.

Collars

A favoured charm for a child was a collar, in the form of a thin metal circle wide enough to pass over the head without an opening. It was supposed to resemble a dog collar and fool bad spirits into thinking the child was a dog. Quite common was a silver ring with an ornament depicting Sau Shing or one of the Eight Immortals attached to the centre, and with beads and charms at each side. Another very popular charm was a silver or brass padlock attached to a metal collar which was hung round the child's neck, thus 'locking him to earth'.

Earrings

All women had their ears pierced, but each ethnic group had its own style of earring. Punti women wore gold ones

carved with lucky symbols such as insects, flowers or coins, while Hakka women wore dangling gold earrings. Jade studs were worn by Tanka women, though some wore earrings looped right over the ear. Hoklo women wore gold charms suspended from rings.

Fans

Fans have been an important accessory for the Chinese for thousands of years. The earliest extant fans made of bamboo were found in one of the Mawangdui tombs dating to 168 BC, and rigid round or oval fans of bamboo or ivory, with silk stretched across the frame, were popular in the Tang dynasty. But it was not until the Song period that the folding fan, made of horn, bone, ivory or sandalwood, was introduced to China from Japan, via Korea. The number of ribs depended on whether it was for a man or a woman: a man's would have nine, sixteen, twenty or twenty-four, while a woman's would have as many as thirty ribs.

A fan was carried not just to create a cooling draught, but also to gesticulate and to indicate status. A wealthy man would carry his fan in a case attached to his girdle, but a coolie would keep it in his stocking top, or in the neck of his jacket. Folding fans were used throughout the year, but palm-leaf and feather fans were used mostly in the summer, and silk ones in early autumn. Indeed, a popular saying referred to a deserted wife as 'an autumn fan', to be put aside when no longer needed.

Palm-leaf fans made of *po kwai* (*Livistona chinensis*) were popular, Xinhui in Guangdong being the centre for this industry up to forty years ago (Figure 19). One tree would produce enough leaves for between five and fifteen fans per year for over a hundred years. While the larger parts of

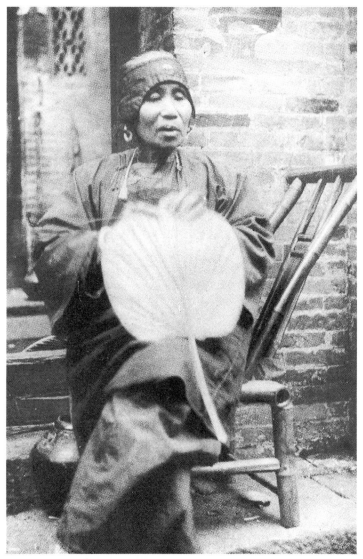

19. Villager wearing a *wai ngak* and making a palm-leaf fan, Xinhui, Guang-
dong, *c.* 1925 (Source: Franck, 1925)

palm leaves were used to make straw raincoats, the ends trimmed off the leaves were used for fans; the ends from the finest quality palm leaves were used for fans with bound edges.

Hair ornaments

Jewellery, especially in the form of hair ornaments, was a convenient way of investing in gold as a means of saving. The pure metal was stamped with a jeweller's mark, thus binding the jeweller by guild law to buy the article back at any time by weight. Silver was not as prized and was often gilded to look like gold.

Hairpins were made of gold, enamel or semi-precious stones such as jade or coral. In particular, those inlaid with kingfisher feathers were very popular. Wedding head-dresses, haircombs, pins and earrings were made by the thousand from these iridescent blue feathers. As recently as the 1930s a factory in Guangzhou was still producing such ornaments. The work of cutting the feathers with a chisel into the size and shape required, and glueing them on to the object, was so delicate that it took many hours to make one item.

Hoklo women wore many elaborate gold ornaments in their hair, especially on festive occasions when it seemed that every decoration a woman possessed was suspended from the bun on her head (Plate 1). Into her hair she pushed jade and gilt butterfly pins, gilt and diamanté stars, and pink wool flowers. Silver and gold decorations hung over the right ear attached by chains to the rest of the ornaments.

For everyday wear the headdresses were replaced by pink wool flowers and strips of crocheted wool, or even wool threads around the bun. Punti women also wore

these bright pink wool decorations, often together with a flat gold hairpin with oval ends, pushed into the bun. Hakka and Tanka women tended not to wear ornaments as their hair was usually covered by a hat or cloth.

Hats and hairstyles

During the Qing dynasty when the Manchus ruled China, all Chinese males, as a sign of subjection, had to wear their hair long in a queue which was the style of the conquering race. Resented at first, the queue was later accepted and became respectable. As a punishment the queue could be cut off, and to be called *mo peen* (literally 'queueless') was a great insult.

The head was shaved by an itinerant barber about once every ten days. At the centre back of the head a circle of hair was left; this was allowed to grow and be plaited into a queue which had to be as long and as thick as possible, and lengthened by adding false hair if necessary. Coolies would wear it coiled round the head when working, but in the presence of a superior it had to hang free. After 1912 it was forbidden to wear the queue, and the custom died out by the 1930s.

For informal wear, and amongst the lower classes, a black satin skull cap with a red or black knotted knob on top was worn and continued to be worn until the end of the 1950s. For formal wear in summer the upper classes wore a conical hat of finely plaited rattan covered with goat hair dyed red. In winter they wore a hat with an upturned brim of black velvet, the crown covered with red fringing.

Unmarried women wore their hair in a long plait down the back and a fringe at the front. After marriage the hair was put up into a bun and dressed with many hair orna-

ments. When a woman reached middle age she would wear an embroidered band across the forehead.

Necklaces

Worn by children, necklaces were made in a variety of different styles. Some were made up of silver charms interspersed with peach stone kernels carved into charms, while others had silver link chains with silver charms attached. Pendants of gold or jade charms were worn by people of all ages as protection against evil: most popular were carved jade buddhas, coins with a hole in the centre surrounded by lucky symbols, and the Pak Kwa.

Paper charms

Paper charms took several forms. In one type, spells against demons were written on yellow paper, burnt, the ashes then mixed with water and the mixture swallowed. Another, popular with the Hoklo people in Hong Kong, was the triangular spell (*sam kok fu*). A charm was written on yellow paper which was then folded into a triangle and pinned to the side of the bun of hair on a woman's head. It was also wrapped in red cloth and suspended from string or a metal ring round the neck of a child who, while on the boat in summer, might be completely naked apart from the charm.

Patterned bands

Patterned woven bands (*fa daai*) were a Hakka tradition and used for securing the waist of the apron, or for tying the *leung mo* or *bau tau* to the head. Made 1 centimetre wide and from 33 to 110 centimetres long, they had a con-

tinuous geometric pattern along the band, culminating in tassels at each end (Figure 16).

There were two main types of patterned band. In general the shorter bands were made of white cotton thread forming the ground colour on which a pattern was picked out in silk of another colour. Longer bands were made of several coloured silks forming both the weave and the tassels.

A woman about to be married would make several patterned bands: for herself, for her prospective mother-in-law, and for other female relatives. Some were treasured possessions to be kept in her dowry chest for wearing on special occasions. The distinguishing features of the bands — the individual patterns — were good luck symbols, most frequently a wish for good fortune and many sons (Figure 16). It was said too that one could tell a woman's status from the colour of her band: a young married woman wore red or pink, an older married woman black or blue, and an unmarried woman green or purple.

The ways in which bands were worn varied according to area and ethnic group. For example, the *bau tau* was fastened in different ways, and on the cool hat in certain areas such as Tai Po in the New Territories of Hong Kong, the bands were cut in half and attached to the top of the hat so that the thick tassels hung over each ear. Punti women were also known to wear the patterned bands, and in some Punti villages in the north-west New Territories the band was continuous and tied under the chin after passing through loops on the hat.

Cotton patterned bands were used by Hakka women on their winter aprons, while both Punti and Hakka liked the richly coloured silk ones for their summer aprons (Plate 14). Buttons sewn to each end of the band attached it through loops to the apron.

Tanka and Hoklo women wore a patterned band (*mo ban*) fixed to their straw hat. These bands were made of small beads which dried more quickly than the woven bands. Women always made their own and passed on the skill to their daughters, unlike the cotton and silk bands which were often bought from those elderly ladies who still possessed the skill. Beads were sold in the markets of the fishing towns, and the loom for weaving was simply made from two pieces of wood, with nylon fishing line wound round it to the desired thickness of the band, which was about 2 centimetres. There were different types of beads, the most popular being the very small coloured ones used to make a pattern several rows wide, sometimes incorporating the characters of the owner's name, with very pleasing effect. Other kinds of beads worn especially by Hoklo women were round plastic ones in a single row, a mixture of round and oval, and a jumble of small ones twisted into a rope.

Personal accessories

There were few pockets in Chinese clothing, and one way of carrying small necessities was by suspending them from a girdle around the waist or pinning them to the clothing. Elaborately carved silver chatelaines were carried, with such items as needlecase, tongue scraper, toothpick, ear-pick, nail cleaner and tweezers, the last being used also for making fabric ball buttons.

Purses

Purses and pouches, and spectacle and snuff bottle cases were carried by both men and women (Figure 20). Some purses consisted of two flaps, one of which hung over the

20. Pedlar selling purses and silks for embroidery, Guangdong, mid-nineteenth century, as depicted in a painting by Tinqua (Source: Urban Council, 1981)

girdle, while others had a drawstring and were tied to the girdle. They were used to carry tobacco, snuff bottles, jewellery, small pieces of jade, and so on.

Thread

There were several traditions concerning thread as a charm. The first was that after the birth of a baby someone from the family would go to neighbours and friends asking for pieces of thread which were then made into a tassel and hung on the baby's clothes. This was called the 'hundred families tassel', which signified the good fortune wished upon the infant by many families. Another tradition, discovered in the village of Muk Wu in the border area of the New Territories, was that on the birth of a child, a mother would put two pins horizontally on the front of the little embroidered cap which the baby wore from the age of one month. Round these pins she would wind red and green thread to signify a desire for long life.

Red cord was also propitious, and usually seen tied to the wrists or ankles of the child and fastened to the jade bracelet or metal bangle. It was also wound around the finger and attached to a ring, presumably to prevent its slipping off inadvertently. This red cord was said to ensure long life, and to fortify the memory (Burkhardt, 1955–9).

8
Fabrics, Dyes and Embroidery

As is evident from the preceding chapters, the range of fabrics used in traditional clothing in south China and Hong Kong was small. Colours too, were limited for the common people, but for the middle and upper classes a greater range of dyes for the main fabrics added variety. For all classes and ethnic groups embroidery was the most important form of embellishment, bringing decorative forms and flashes of bright colours to the generally sombre colours of their fabrics.

Fabrics

Traditional Chinese clothing utilizes only three main types of fabric: hemp, cotton and silk. Hemp and cotton were worn by the poorer people, while silk was the fabric favoured by the rich.

Hemp (*ma po*) has been grown in China since the third millennium BC, and during the Han dynasty most of the population was clothed in fabric made of hemp (Loewe, 1968). It remained an important fabric until the middle of the thirteenth century, when cotton gradually became the main fabric used by the common people. However, hemp continued to be grown domestically, and even up to the early part of the twentieth century it was cultivated by villagers in the north-east New Territories to be made into fabric for clothing.

The hemp plant (*Cannabis sativa*) is an annual. Three crops a year were grown, the first in June, the second

about six weeks later, and the final one in October which was expected to produce the finest cloth. It was usual for the women in the villages to spin the fibres and to prepare the yarn for weaving. However, the task of actually turning the yarn into cloth fell to groups of itinerant weavers who travelled from village to village during the autumn, after the hemp had been harvested. They would stay in an empty house in the village, and weave the cloth on simple looms, using tools they had brought with them. Afterwards the cloth would be dyed and made into clothing (Hayes, 1968).

Hemp cloth was stiff when new, but it softened with age and was popular because it felt cool in summer. Coarse undyed hemp was used for funeral clothing, and lengths of black, firmly woven hemp cloth, 'enough for three sets of clothes', were on sale in Tai Po market in Hong Kong in the summer of 1979, the width being 49 centimetres. Ramie, a finer fabric produced from a plant in the same family as hemp, was used by wealthy Chinese men, especially for their summer robes. It was produced by hand in the same way as hemp, but it was silkier in appearance and took dye more easily.

Cotton was grown in China on a very large scale, though the plant was not indigenous to the country, having been introduced from India through South-east Asia in the Song dynasty (Dietrich, 1972). It was first grown in the northern provinces, but later spread south to the basin of the Yangtze river, proving that it could withstand both the cold winters in the north and the hot summers in the south. When cotton first appeared there was opposition from the silk and hemp growers, and it was not until the Yuan dynasty (1271–1368) that cotton was fully accepted.

From the mid-nineteenth century the demand for raw cotton was unprecedented and it continued to be the main import from India, along with opium, until the end of the century. It has been estimated that 90 per cent of Chinese peasants wore cotton clothing, such was the popularity of the fabric. From a cottage industry, the production of cotton fabric developed rapidly into a large commercial enterprise. By 1924 there were more than seventy cotton mills in China, with six of the main ones in Shanghai, the centre of the cotton-growing area. The quantity grown was still insufficient to meet local demand, and so additional cotton was imported from America and from England. Most of the cotton used for clothing in Hong Kong was imported from China.

Another fabric which was popular in the past, especially during the 1920s and 30s, and particularly with the labouring classes who found it cool to wear and easy to care for, was black gummed silk (*hak gow chau* or *hak gow sa*). The silk has a distinctive black shiny surface with a matt brown underside and a small geometric weave of varying designs. It was worn in the areas south of the Yangtze river and has been made in the district of Shunde in Guangdong province for over two hundred years.

The silk is dyed with a solution made from the fruit of the false gambier plant (*shu leung*) which is harvested once a year. To produce the dye the fruit, which resembles the potato, is cut in half, mashed and mixed with water; the orange-brown mixture is then strained. After the silk has been dipped into the dye, it is left to dry in the sun. This process is repeated many times after which the fabric is plastered with mud from a nearby river said to have special properties not found elsewhere. The mud is left to dry in the sun, and then the silk is washed to reveal the familiar black glaze. After this it is said that the juice of unripe

persimmons is applied as varnish to the outside of the cloth to make it waterproof.

This water-resistant property made gummed silk especially popular with boat people as it does not cling to the body when wet. The fabric loses its initial stiffness after it has been worn for some time, and it may be washed without soap. The width of the fabric is usually about 78 centimetres.

As with the growing of hemp, there is a long tradition of sericulture in China dating back to around 3000 BC, cut silkworm cocoons having been found in excavations of sites of that period. In the second century BC, a route, stretching some 11,000 kilometres, was opened from Chang'an in Shaanxi province, the capital of China as well as the centre of silk production, through Gansu and Xinjiang in north-west China to Afghanistan, and then round Iran to Hierapolis in Syria. This became known as the Silk Road, and it was along this route that China exported its silks to the West.

During the Han dynasty silk weaving reached new heights, and richly coloured brocades and gossamer fine gauzes have been excavated from tombs of this period. In addition to being an expensive and treasured fabric, silk was a form of currency, and a favoured gift to pacify potential aggressors. The fact that over two hundred common Chinese characters had the element for silk as their radical may be seen as an indication of its importance in everyday life.

By the end of the nineteenth century silk had overtaken tea as China's leading export commodity. The great silk-producing regions were Zhejiang province, of which Hangzhou and Huchow were the main centres, and Jiangsu province, of which Suzhou and Wuxi were the main centres. Huge quantities of silk were exported, but even

larger quantities were needed for the home market. Many different varieties were woven, such as crêpe, brocade, raw silk, satin, damask, pongee, and gauze.

Dyes

There is little written information on precisely how the Chinese dyed cloth: like many skills it was a knowledge based on experience and was handed down through the generations by word of mouth. There were no formal recipes, and details such as the proportion of the ingredients, the length of time it took to dye the cloth, and the number of times the fabric was immersed to achieve the desired colour, were all factors which were known to individual dyers and were often jealously guarded secrets.

Until the mid-nineteenth century most dyes came from plants, and are thus known as vegetable dyes. Some plants gave a fast dye, that is, the colour would not wash out, but many were not fast and required a mordant (from the Latin *mordere*, meaning 'to bite'), a substance used to fix the colour into the fabric. The mordant further enabled the fabric to take the colour successfully, thus enhancing it. Mordanting is done before dyeing, the wet yarn or fabric being immersed in the solution for the required length of time. Different mordants would produce different shades with the same plant dyes.

The main mordants used by the Chinese were as follows: alum or potash, obtained by boiling hemp or rice straw; iron, obtained by boiling iron shavings, nails, and so on; and slaked lime, obtained from sea-shells. Chrome and tin are also mordants, as is tannic acid which is present in some dye plants such as sumac and gall nuts.

Blue was by far the most common colour worn by the working classes and it was obtained from the indigo plant

(*Indigofera tinctoria*), known as *lam cho*, meaning 'blue grass'. The plant has been used for dyeing for centuries in China, and was grown in the central and southern provinces, particularly in the Yangtze river valley, with much of it going to Foshan near Guangzhou to be used in the dyeing works there.

The plants were collected at the flowering stage and thrown into large tanks filled with water. Lime was added and the plants left to soak for some days, during which time they were shaken and stirred to release the dyeing matter. The extract was then removed and churned up to expose it to air. At first the extract was a greenish yellow, but through oxidization it changed to deep blue. When ready the pigment sank as a precipitate and the liquid was removed, the thick mass at the bottom being the blue dye. After dyeing, the cloth was washed, and then sized if required, the size being usually tinted with methyl violet (a coal tar dye) which imparted a copper lustre to the cloth (Watson, 1930).

Other common colours were red and black. Red was produced from safflowers (*Carthamus tinctorius*) or sapan wood (*Caesalpinia sappan*) which had to be used with the correct mordants as the dye was fugitive and not fast on cotton. Black could be achieved from gall nuts when applied to cloth which had first been dyed blue. Acorns from the chestnut oak (*Quercus serrata*) also made a good black when mordanted with iron. A third method was to heat ivory shavings in a closed container; this produced ivory black. Animal bones were sometimes used but the black thus obtained was not as deep or as velvety.

The methyl violet dye which tinted the size for the indigo-dyed cloth was the forerunner of the chemical dyes developed in 1856. This signalled the demise of the natural vegetable dyes, and the rise in popularity of syn-

thetic or aniline dyes which could be obtained easily and relatively inexpensively.

Embroidery

It has been said that the embroidery produced by the Chinese is the equivalent of Western oil painting; indeed, Chinese embroidery was so finely executed that the Romans called it 'painting with the needle'.

Embroidered clothing has a long history in China, probably dating back 5,000 years to the time when sericulture was invented. Symbolism has always been an important part of Chinese life, and embroidered symbols on clothing were a way of indicating a person's rank, as well as putting him in good favour with the supernatural powers. During the Han dynasty embroidery flourished under court patronage, and the discovery at Mawangdui in Changsha in 1972 of the Han tomb of the wife of the Marquis of Dai brought to light many examples of sophisticated and well executed pieces of embroidery. In later dynasties embroidery was further refined, becoming more diverse in subject matter and in the types of stitches, and used to ornament all kinds of furnishings and accessories as well as garments.

Unfortunately, fabric and embroidery do not survive the ravages of time as well as, for example, ceramics or objects of metal or stone, and little from very early times is extant today. More examples have survived from the Ming dynasty, however, with those made by members of the Gu family being highly prized. Bright colours are distinctive of this period, and a variety of materials was used along with the silks, including human hair, ostrich and cock feathers, gold thread and precious stones.

During the Qing dynasty the art of embroidery was

further developed and certain cities in China became celebrated as centres of embroidery, in particular Suzhou and Guangzhou. By the middle of the dynasty embroidery was an industry in its own right, with men, women and children engaged in its manufacture. Ladies in well-to-do households learnt to do embroidery as a feminine accomplishment, but such households would employ an embroiderer to produce the many articles they required. The task was left to the wives and daughters of tradesmen and artisans who learnt to embroider as a means of contributing to the family income. Almost every garment worn by a middle- and upper-class Chinese would be embellished with embroidery. There were the official robes and the badges of rank worn by the mandarins and their wives, jackets and skirts for women, clothing for children, headwear for adults and children, purses for a variety of uses, shoes, and all the necessary soft furnishings for middle- and upper-class homes.

Silks for embroidery were bought from itinerant pedlars (Figure 20) who walked the streets announcing their wares by twirling a rattle. They carried small drawers of every shade of floss silk imaginable, as well as silver and gold. The base cloth for embroidering upon was usually silk, of every weight from gauze to satin. Cotton was used by the lower classes, especially as a base for appliqué work. The relatively small repertoire of stitches was confined to brick, buttonhole, chain, couching, cross, long and short, pekinese, satin, seed and stem stitches.

Birds and flowers, landscape and genre scenes, figures from history and folklore, and, above all, objects and characters with auspicious connotations formed the repertoire of embroidery motifs. Inexpensive books of embroidery designs were popular, in which the approved styles of embroidery and the arrangement of colours and patterns

were set out. Rice paper-cuts, made in Foshan for pasting on to the paper windows found in many homes in China, were also used as a base for design. The embroidery was either worked over the paper-cut or the edge of the paper design was sewn round as an outline and the paper then ripped out. Another method entailed the use of a white powder made of ground oyster shells which was dusted through a stencil, leaving a powdery outline. More powder was mixed with water and a fine line painted over the outline to render it more permanent. The design was then embroidered.

Stencils of the most popular designs and symbols were made, and most large studios had a selection of cardboard templates which were used to give uniformity in design, to assist in the placing of the design, and to save time. All the popular symbols such as the *sau* character, bat, cloud filler and common Buddhist and Daoist symbols were made in this way.

9
Conclusion

To collect data for this book it was necessary to look back over several centuries of Chinese clothing traditions, and the first thing one noted was how little the styling changed. The Chinese, in particular the common people, having developed a vernacular form of dress which was eminently suited to their predominantly rural way of life, kept the same styles virtually unchanged for long periods. The basic garments of the working people in Hong Kong and south China were simple in construction and not as colourful as the costumes of some of China's minority groups or the formal costumes of the Manchu court. But unexpected flashes of colour and embroidery found on clothing in this region such as aprons and headwear, and especially on children's wear, have a vibrance which lent a renewed excitement to each new discovery.

Political upheavals during the middle years of the twentieth century have destroyed many of the old clothing traditions in China, and now urban development and a predilection for things imported from the West have done the same in the New Territories of Hong Kong. On visits to this area over the years it has been noticeable that the wearing of traditional clothing is in decline. Nowadays it is becoming quite rare to see the old styles and clothing customs, although the fishing population, being more superstitious, cling to the old ways long after land-dwellers have rejected them. Much of what has been described and illustrated in this book must now sadly be relegated to history.

Glossary

Terms are given first in romanized Cantonese, followed by their Pinyin equivalents and the Chinese characters in parentheses.

baak tau do lo (*bai tou dao lao* 白頭到老) literally 'white head, old age', a fanciful way of referring to the white waistband, as well as a wish for long life and a blessing in a Chinese marriage.

bau tau (*bao tou* 包頭) literally 'head wrap', headcloth worn by Hakka women.

cheung sam (*chang shan* 長衫) literally 'long dress', fastening over to the right. Worn by men and women, but for women the term refers to a fitted dress, usually calf-length. Equivalent term for women's *cheung sam* in north China is *qi pao* 旗袍, literally 'banner gown'. The term indicates the Manchu origin of this garment, 'banner' being one of the divisions of the Manchu army.

chiu yiu king (*zhao yao jing* 照妖鏡) literally 'demon-deflecting mirror', a metal disk which acts like a mirror worn by brides to deflect evil influences.

cho hai (*cao xie* 草鞋) sandals made of rice straw, wheat straw or rushes.

daai hau (*dai xiao* 帶孝) the custom of wearing a white, blue or green wool flower in her hair by a woman in mourning for her husband/parent, grandparent or great-grandparent respectively, and of a pink wool flower to denote end of mourning; also refers to the wearing of a black ribbon fastened to upper garment by a man in mourning.

Dai Wong Yeh (Da Wang Ye 大王爺) a local earth god who gave his name to a Hoklo festival celebrated annually.

doi hau (*dai kou* 袋口) literally 'pocket mouths', pockets of a man's jacket, especially the inside pockets, a punning refer-

ence to the number of his children, namely, the number of mouths to feed.

fa daai (*hua dai* 花帶) patterned woven band.

fa lap (*hua li* 花笠) embroidered headband worn by Punti women.

fu (*ku* 褲) loose-fitting trousers.

fu tau (*ku tou* 褲頭) waistband of trousers.

Fuk, Luk, Sau (Fu, Lu, Shou 福祿壽) three mythological figures denoting good fortune, an abundance of good things, and long life respectively.

hak gow chau (*hei jiao chou* 黑膠綢), *hak gow sa* (*hei jiao sha* 黑膠紗) black gummed silk.

Hakka (Kejia 客家) literally 'guest people', not indigenous to the area.

hoi min (*kai mian* 開面) literally 'to open the face', to remove hairs from over the forehead with two red threads.

Hoklo (Fulao 福佬) literally 'men from the Hok', Hok being the Cantonese name for Fujian (Hokkien) province.

hung kwa (*hong gua* 紅褂) red jacket and skirt worn by bride.

kau niu (*kou niu* 扣鈕) literally 'to do up a button'; the phrase is a homonym of *kau lau* (*kou liu* 扣留), meaning 'to detain against one's will'.

kowtow (*kou tou* 叩頭) literally 'to knock the head', to perform obeisance by prostrating the body and knocking the head on the floor, a gesture of great deference to an elder or superior.

laisee (*li shi* 利市) money given in a red envelope for a special occasion, usually at Lunar New Year.

lam cho (*lan cao* 藍草) literally 'blue grass', indigo plant producing a blue dye.

leung mo (*liang mao* 涼帽) literally 'cool hat', circular straw hat with black cloth fringe worn by Hakka women.

ling tze (*ling zi* 鈴子) bells worn by children to frighten evil spirits.

ma kwa (*ma gua* 馬褂) literally 'riding dress', short black jacket worn over man's *cheung sam*.

ma po (*ma bu* 麻布) hemp.

mo ban (*mao ban* 帽斑) beaded band used with Tanka straw hat.

mo peen (*wu bian* 無辮) literally 'queueless', to be without a queue on one's head.

ng fuk (*wu fu* 五服) five grades of mourning clothing.

Pak Kwa (Ba Gua 八卦) Eight Trigrams, ancient system of divination.

po kwai (*pu kui* 蒲葵) *Livistona chinensis*; leaves from this tree were used to make palm-leaf fans.

pui sum (*bei xin* 背心) satin waistcoat worn by boys over their *cheung sam*.

Punti (Bunde 本地) person born locally and whose native tongue is Cantonese.

sam (*shan* 衫) upper garment fastening over to the right.

sam kok fu (*san jiao fu* 三角符) red triangular cloth amulet with paper charm inside; worn by women and young children.

Sau Shing (Shou Xing 壽星) God of Longevity.

sau yee (*shou yi* 壽衣) literally 'long-life dress'; worn for sixtieth birthday celebrations and after, and for burial.

shu leung (*shu liang* 薯莨) false gambier, a dye plant.

Shui sheung yan (Shui shang ren 水上人) literally 'people who live on the water', an alternative name for the Tanka people.

so yee (*suo yi* 蓑衣) straw raincoat.

Ta Tsiu (Da Jiao 打醮) ceremony held every ten years to pacify the dragon.

Tanka or Daan ga (Danjia 蛋家) literally 'egg people', popular name for boat people; cf Shui sheung yan.

tau kam (*tou jin* 頭襟) curved opening on the *sam*.

wai kwan (*wei qun* 圍裙) apron.

wai ngak (*wei e* 圍額) plain headband worn by Punti women.

yin and *yang* (*yin* and *yang* 陰陽) negative and positive cosmological symbols; *yin* also represents earth and the female, while *yang* represents heaven and the male.

Bibliography

Baker, Hugh D.R., 'The Five Great Clans', *Journal of the Hong Kong Branch of the Royal Asiatic Society*, Vol. 6 (1966), pp. 26–7.

Burkhardt, V.R., *Chinese Creeds and Customs, Vols 1–3*, South China Morning Post, Hong Kong, 1955–9.

Ball, J. Dyer, *Things Chinese*, fifth edition, Kelly and Walsh, Shanghai, 1925.

Cheng, Irene, *Clara Hotung: A Hong Kong Lady, Her Family and Her Times*, Chinese University Press, Hong Kong, 1976.

Dietrich, C., 'Cotton Culture and Manufacture in Early Ch'ing China', *Economic Organizations in Chinese Society*, Stanford University Press, 1972, pp. 109–11.

Doolittle, Rev. J., *Social Life of the Chinese, Vols I and II*, New York, 1865.

Dudgeon, John, *Diet, Dress and Dwellings of the Chinese in relation to health*, International Health Exhibition 1884, China, 1885.

Franck, Harry A., *Roving Through Southern China*, The Century Co., New York, 1925.

Goodrich, L. Carrington, *15th Century Illustrated Chinese Primer, Hsin-pien tui-hsiang szu-yen*, Hong Kong University Press, Hong Kong, 1975.

Hayes, James, 'Itinerant Hakka Weavers', *Journal of the Hong Kong Branch of the Royal Asiatic Society*, Vol. 8 (1968), pp. 162–5.

Hayes, James, 'Hemp', *Journal of the Hong Kong Branch of the Royal Asiatic Society*, Vol. 10 (1970), pp. 188–90.

Levy, Howard S., *Chinese Footbinding*, Neville Spearman, London, 1966.

Loewe, Michael, *Everyday Life in Early Imperial China*, Batsford, London, 1968.

Osgood, C., *The Chinese: A Study of a Hong Kong Community, Vols I–III*, University of Arizona Press, Tucson, 1975.

Pendleton, Robert L., 'Notes on Kwangtung Fibres', *Lingnan Science Journal*, Lingnan University, Vol. 12 (1933), pp. 409–13.

Scott, A.C., *Chinese Costume in Transition*, Donald Moore, Singapore, 1958.

Seton, G.T., *Chinese Lanterns*, Dodd, Mead & Co, New York, 1924.

Sirr, H.S., *China and the Chinese*, W.S. Orr & Co, London, 1849.

Urban Council, *Pearl River In The Nineteenth Century*, Hong Kong, 1981.

Vollmer, John E., *In the Presence of the Dragon Throne*, Royal Ontario Museum, Toronto, 1977.

Vollmer, John E., *Decoding Dragons*, University of Oregon Museum of Art, Eugene, 1983.

Warner, J., *Fragrant Harbour*, John Warner Publications, Hong Kong, 1976.

Watson, E., *The Principal Articles of Chinese Commerce*, Shanghai, 1930.

Williams, C.A.S., *Outlines of Chinese Symbolism and Art Motives*, Customs College Press, Peking, 1931.

Young Yang Chung, *The Art of Oriental Embroidery*, Scribners, New York, 1979.

Index